PRINCIPLES OF
COMPOSITION
IN PHOTOGRAPHY

PRINCIPLES OF
COMPOSITION
IN PHOTOGRAPHY

by Andreas Feininger

AMPHOTO

American Photographic Book Publishing Company, Inc.

GARDEN CITY, NEW YORK

Fourth Printing, 1978

Library of Congress Catalog Card Number 72-77136.
Printed in the United States of America.

Other books by ANDREAS FEININGER

Light and Lighting in Photography (1976)
Roots of Art (1975)
The Perfect Photograph (1974)
Darkroom Techniques (1974)
Photographic Seeing (1973)
Shells (1972)
Basic Color Photography (1972)
Total Picture Control (1970)
The Color Photo Book (1969)
Trees (1968)
Forms of Nature and Life (1966)
The Complete Photographer (1965)
New York (1964)
The World Through My Eyes (1963)
Maids, Madonnas and Witches (1961)
Man and Stone (1961)
The Anatomy of Nature (1956)
Changing America (1955)
The Creative Photographer (1955)
Successful Color Photography (1954)
Successful Photography (1954)
The Face of New York (1954)
Advanced Photography (1952)
Feininger on Photography (1949)
New York (1945)
New Paths in Photography (1939)

Table of Contents

I. Technique + Art = Effective Photograph 9

II. The Purpose of Composition 12

III. The Nature of Composition 18

The academic rules of composition 19 • The nature of composition 20 • A total subject approach 21 • The ability to see reality in photographic terms 22 • Differences in seeing between eye and camera 23 • How to see reality in photographic terms 25 • The viewing frame 25 • In regard to color rendition . . . 26 • In regard to motion rendition . . . 28

IV. The Principles of Composition 29

Exploration 29

Direct light; diffused light; front light; side light; backlight; light from above 30 • The camera can move, the subject is stationary 31 • The relationship between subject, foreground, and background 31 • The direction and character of the incident light 34 • The camera is stationary, the subject moves 35 • Both the camera and the subject can move 36

Isolation 38

Isolation by means of subject distance 40 • Isolation by means of the focal length of the lens 41 • Isolation by means of selective focus 42 • Isolation by means of light 42 • Isolation through change of background 43 • Isolation by means of color filters 43 • Summing up 44

Organization 45

The proportions of the picture 49 • The rectangle 49 • The square 51 • The circle 53 • Practical considerations 54 • Subject position and angle of view 56 • Camera position and angle of view 58 • The role of the illumination 64 • Cropping on the film 66 • Cropping the print 68 Corrections during printing 74 • Perspective control 74 • Contrast high or low? 76 • Lighter or darker print? 77 • High contrast: black and white 78 • The Golden Section 82

V. The Elements of Composition 86

"True" lines through solarization 89 • Bold lines through bas-relief 90 • The character of lines 91 • The outline 91 • Converging verticals; diagonals; jagged lines; curving lines; leading lines; lines of arrangement or composition; lines of motion or force 93 • The "line" of the horizon 94 • Composing with color 96 • Complementary colors 98 • Related colors 99 • Pastel shades 100 • Gray as color 101 • Black as color 102 • White as color 103 • Background and foreground 104 • Three sculptures by David Smith 105 • The principle of scale 108

VI. The Forms of Composition 110

Static composition 110 • Examples of static composition 112 • Symmetry in composition 114 • Central composition 116 • Framing the subject 118 • Dynamic composition 120 • Dynamic balance 121 • Static or dynamic composition? 122 • Pattern and composition 126 • Composition in practice 130 • The approach of the amateur 130 • The approach of the professional photographer 130 • Summing up 136

I. Technique + Art = Effective Photograph

Every good photograph is the result of a successful synthesis of technique and art. In this respect, the importance of the role played by technique should be apparent to anyone from casual snapshooter to successful professional: poor photo-technique can only lead to pictures that are unsharp, off-color, too light, or too dark — a waste of effort, money, and time. Mastery of photo-technique is obviously the first requirement for making good photographs.

However, we all have seen photographs that have left us cold despite the fact that they were "technically" unassailable, *i.e.*, sharply rendered, correctly exposed and developed, and satisfactory in regard to contrast and color. They failed to arouse our interest because the subject was hackneyed, badly "seen," and presented in a form that was graphically dull. Evidently, unless complemented by art, not even the most accomplished technique can guarantee the production of effective photographs.

On the other hand, a photographer may be artistically gifted, sensitive to feelings and mood, and perceptive to beauty, but unless he is also an accomplished photo-technician, his talent will be wasted because he will be unable to communicate his visions through the picture language of photography: lack of "technique" will always prevent him from expressing himself effectively in photographic form.

In photography, in contrast to art, technique is easy because it is specific, tangible, objective. It can be reduced to numbers and readings taken from instruments: film speed and f/stop numbers; inches (focal length of lenses) and feet (subject distances); seconds (shutter speeds) and minutes (film development); degrees F (film developer) and degrees K (color of light). Any film has its specific ASA speed number, which can be found in the instructions that accompany every roll and box of film. Focusing (for sharpness) and stopping down the lens (for sharpness in depth) proceed with the aid of a split-image or microprism rangefinder (or a groundglass) in conjunction with the depth-of-field calculator scale on the camera. Brightness

of illumination is measured with an exposure meter, which instantly reveals all the applicable combinations of f/number and shutter speed. Flash exposure is calculated on the basis of guide numbers furnished by the speedlight manufacturer. Film development proceeds in accordance with the data for duration (minutes) and temperature (degrees F) packed with every box and roll of film. As a result, anyone who can read and follow simple instructions should also be able to make technically perfect photographs, an accomplishment that experienced photographers take for granted as much as it is generally taken for granted that a writer is able to construct effective sentences and spell correctly.

In contrast to technique, art in photography, a most elusive concept, is difficult because it is non-specific, intangible, subjective. It involves the application of taste, discrimination, and sensitivity in conjunction with such factors as camera position and angle of view, subject distance and image scale, perspective, juxtaposition and overlapping of picture elements, contrast range and tonal gradation, color and color arrangement, picture proportions, and so on. All these factors have one quality in common: They are non-specific insofar as *they offer the photographer a choice.* Choice of angle of view — should he take his picture more from the right or from the left, more from above or from below, and what are the consequences in regard to perspective, foreground, background, and direction of light? Choice of camera distance — should he step back or go closer to include more or less of his subject or change the scale of rendition? Will front-, side-, or backlight give the best result? Do colors harmonize or clash? Should subject motion be frozen or indicated by means of a carefully chosen degree of blur? Should the picture be composed horizontally, vertically, or in the form of a square?

This, then, is the problem: When it comes to art, a photographer is on his own. He is the doctor. He must make the decision, because only he can know what he wants to do, what he intends his picture to say. *He has to make a choice* — many times, all the time. How he makes his choice decides whether his photographs will turn out good, bad, or indifferent.

Unfortunately, art in photography is a concept as elusive, personal, and difficult to define as happiness, taste, or truth. A photograph considered artistic by one person may well be called pictorial trash by another, and the rules of composition cherished by some photographers may be derided by others. Obviously, the whole concept of art in photography is a very intuitive and subjective one, extremely controversial (because no two photographers agree on all points) and almost impossible to define. If, in the following

10

pages, I still dare to step where angels fear to tread, it can only be with the understanding that everything I have to say represents my personal opinion and that I fully respect the reader's right to disagree with me. But before I begin my discussion, I would like to suggest that, instead of talking about *art* in photography, we talk about *composition*, a less pretentious term. Composition means almost (but not quite) the same as art and is familiar to most photographers, although few are able to define it and many think that the purpose of composition is to formalize the relationship of all the picture elements in accordance with specific academic rules. Since nothing can be further from the truth, let's start by clarifying the purpose of composition.

II. The Purpose of Composition

No matter how violently photographers may disagree in regard to specific aspects of composition, they all agree in one point: A well-composed photograph is more effective and makes a stronger impression than a badly composed one, a fact that can only lead to the conclusion that the purpose of composition is to heighten the effect of the picture.

In a general sense, of course, every photograph is composed, no matter how unconsciously or how badly. Even the snapshooter who takes the time and trouble to align the subject in the viewfinder of his camera before he takes the picture is composing, although such composing is of the lowest order, limited to centering the image of a person within the boundaries of the future picture and trying to avoid cutting off his or her head.

In practice, differences in composition often provide the only difference among photographs taken by different photographers of the same subject at the same time. As far as the technical aspects of such pictures are concerned — degree of sharpness, correctness of exposure, mode of development and printing — there may be no differences at all since all were made under identical conditions. But in regard to composition — manifested in the form of such factors as camera distance, scale of rendition, angle of view, perspective, and arrangement of the various subject components within the frame of the picture — there may be all the difference in the world, making one or a few pictures more effective and hence better than the rest. Good composition could therefore be called the secret weapon of the visually aware photographer who, despite the fact that he photographs the same subjects using the same type of camera and film, exposure and mode of development as his colleagues, consistently produces pictures that are superior in graphic and emotional impact to those made by his less sensitive and knowledgeable competitors. Composition is usually the most effective and often the only way in which a photographer can express his individuality.

The importance of the role composition plays in the effect of a rendition is further illustrated by the fact that two forms of graphic rendition exist —

12

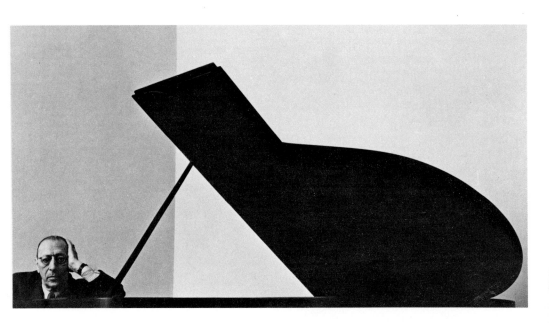

Igor Stravinsky photographed by Arnold Newman. Anybody can photograph a pianist sitting at the piano, but it takes a sensitive artist to create a picture as unusual, effective, and memorable as this one. Although this picture was produced with ordinary equipment under ordinary shooting conditions, its outstanding composition leaves an unforgettable impression.

not only in photography but also in painting — which derive their justification solely from composition. These are still lifes and abstractions, two art forms specifically created to evoke the aesthetic pleasure and satisfaction that can be derived from good composition. In subject matter, still lifes are usually extremely dull. Who cares about seeing pictures of apples or oranges, spun aluminum plates, pewter pitchers, or any of the other paraphernalia of which most still lifes are composed? And abstractions are usually entirely devoid of recognizable subject matter. What makes such studies potentially interesting and enjoyable is the way in which they are composed. If the composition is academic and dull, still lifes and abstractions are, at least in my opinion, the most senseless of all picture forms. But if they are well-composed, they can be extraordinarily satisfying to any sensitive and aesthetically receptive viewer.

Photographers intent on developing their sense of composition are urged to study good abstract and semi-abstract paintings. Consider, for example,

13

New York Wall, by Aaron Siskind, 1951. Although a straight photograph, this picture is spiritually related to modern abstract art with which it has one characteristic in common: Subject matter is totally irrelevant, design and composition are everything. Siskind, who became famous for his photographs of walls covered with peeling paint, is perhaps the most design-conscious of all contemporary photographers.

14

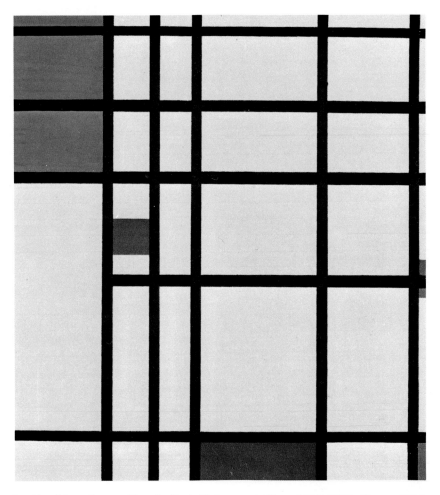

Piet Mondrian, Composition in Red, Yellow and Blue, 1936–1943 (by permission of Moderna Museet, Stockholm). Embodiment of the essence of dynamic balance (see p. 121)—precisely aligned horizontal and vertical lines sensitively spaced and accentuated by carefully placed rectangles of pure, primary colors the effect of which, unfortunately, is here lost in the black-and-white reproduction. The resulting feeling of balance and harmony is aesthetically extremely satisfying.

the three works by Piet Mondrian, Franz Kline, and Lyonel Feininger reproduced here. Notice that the first two are examples of "pure" composition since they are completely non-representational and derive their entire effect

15

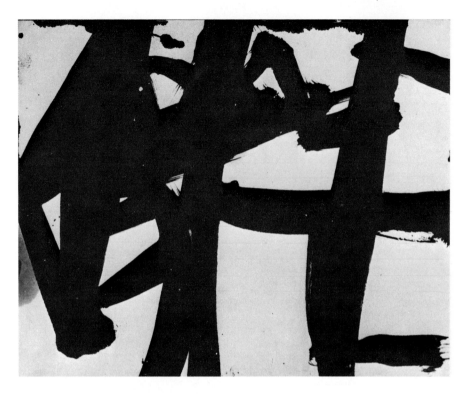

Franz Kline, untitled (ink on paper, ca. 1951). Embodiment of the essence of a dynamic composition (see p. 120)—a pattern of slashing diagonals in bold strokes of paint splintering space and evoking feelings of action, violence, and power, symbolic of the drama of life.

from composition alone, whereas the third uses composition as a means for achieving the highest degree of order and organization in regard to the elements of the picture.

Although in photography, where control over the subject is, of course, much more limited than in painting, few compositions will ever be as pure and perfect as those of the paintings reproduced here, it is nevertheless important that a photographer strive right from the start to organize his subject matter in a specific compositional form: static, dynamic, central, diagonal, and so on. While it may be impossible to achieve a "perfect" result in this respect, even an imperfect but definite composition will produce a stronger effect than an indefinite, wishy-washy one. Later in this book (pp. 110–125),

16

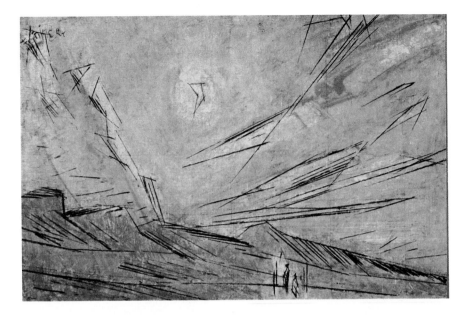

Lyonel Feininger, Weird Moon. Example of the practical use of composition as a means for organizing the elements of a semi-abstract, representational painting and presenting them in the graphically strongest, most effective form. Notice that most of the spacings, space relationships, and proportions are based upon the "Golden Section," of which more will be said on p. 82. In this case, using the same ratio of approximately 5:8 as the basis on which to assign space to the most important elements of the painting in relation to its boundaries (the location of the group of people on the beach and the position of the moon) and to determine the proportions between earth and sky, the artist achieved a unity of effect that could not have been created in any other way.

I will discuss the different forms of composition one at a time and, for clarity's sake, illustrate each with photographs showing the respective type in its purest form. This must not discourage the reader who might find it difficult or impossible to organize his subject matter with the same clarity and precision. It is the principle that matters, the fact, that the picture was organized at all along specific compositional lines. The degree to which such an ideal can be realized is of less importance, although, of course, a higher degree of organization will produce a stronger impression than that evoked by a less well organized photograph. The main thing is that the photographer should be aware of the purpose and nature of composition and familiar with its means. All else will come with practice.

III. The Nature of Composition

My dictionary defines *composing* as "giving form by putting together." Giving form to what? The ideas, concepts, opinions, feelings, and intentions of the photographer, of course. Putting together what? Obviously, all the factors that combine to make the picture: the characteristic features of the subject, its background and foreground, outline and forms, color or shades of gray; the distribution of light and shadow, black and white; subject scale and angle of view; perspective in terms of foreshortening and diminution, juxtaposition and overlapping of forms; arrangement of and relationship among the various picture components; the position of the horizon; the boundaries and proportions of the print. In short, all the different picture elements which, by the way they are used by the photographer, determine whether his message is conveyed to the viewer of the picture in a graphically effective or ineffective form. The importance of the role that composition plays in the final impression of the transparency or print should therefore make it obvious that composing is something that must not be taken lightly nor, like cropping, be introduced as an afterthought during enlarging. It is an essential aspect of picture-making, ranking in importance with such nuts-and-bolts techniques as focusing, exposing, developing, and printing.

Before I go any further, I would like to digress for a moment in order to clear away some obsolete ideas still found in many photographers' heads. Besides, it has been my experience, in teaching, that a negative approach is sometimes more effective than a positive one. By this I mean to say that it is often simpler to state what a thing is not than what it is, and easier to say what to avoid than what to do. For this reason, before I give my own definition of composition, I'll list the most frequently quoted academic rules of composition, which, in my opinion, are at best half-truths and at worst indefensible restrictions or downright fallacies.

As I see it, in photography, even the few acceptable rules of composition are nothing but suggestions that the photographer should consider as a check-list and then be free either to follow or to disregard them. Valid exceptions can be found to even the most ironclad rules, and breaking the

18

rules is sometimes the best way to produce a stunning photograph — provided the photographer knows what he is doing.

The "Golden Section" (or "Golden Mean") is not a cure-all, although its use assures pleasant proportions. Because of its placid effect, the Golden Section may even produce tensionless and therefore boring results. More about this on p. 82.

Like the Golden Section, a composition in the form of an "S"-curve is not an infallible device for producing interesting photographs. In fact, the "S"-curve is perhaps the most hackneyed of all pictorial clichés. ★

The entire theory of leading lines — lines that allegedly lead the viewer's eye to the so-called center of interest in the picture — is a fallacy. Scientific investigation of this theory with the aid of special "eye-cameras," which record the movements of the viewer's eyes, have proven that the eye instantly focuses on that part of the picture that arouses the greatest interest, completely disregarding all those lovingly prepared leading lines. Furthermore, the viewer's center of interest does not necessarily coincide with that intended by the photographer. ★

Compositions based upon triangles, opposed diagonals, dignified curves, and so on — staple items of most dissertations on composition and in textbooks usually illustrated with carefully drawn line diagrams — exist only in the minds of the photographers who made them and of certain academicians who still teach the "old" photography. As a matter of fact, with a little bit of trying, by cropping here and there and using some imagination, almost any random photograph can be forced to conform to some kind of post-conceived "composition," triangular or otherwise. However, the unbiased viewer of the picture usually does not recognize such an arrangement even when it is pointed out to him, and then couldn't care less.

The horizon, or any important line, should never divide a photograph into two equal parts because the effect would be monotonous. But what if a photographer should wish to illustrate the concept of monotony in his picture?

Movement or action should always proceed from left to right because this is the way we read. An indefensible stand, of course. Besides, Hebrew is read from right to left.

In a photograph, the space in front of a subject in motion should always be larger than the space behind it. A fallacy: A moving subject placed close to the edge of the picture toward which it moves suggests arrival, a concept that is often important as, for example, in racing.

In portraiture, if the subject does not look straight at the camera, more space should be left in the direction of the gaze than behind the head. Not necessarily true, particularly if tension should be suggested.

Light picture areas attract the eye before dark ones. This is complete nonsense. Any dark bold form surrounded by an extensive light area provides an instant focal point of interest, while the light surrounding it is disregarded as background.

Repetition of identical or similar picture elements makes particularly interesting photographs, the so-called "pattern shots." Totally untrue. There is no earthly reason why a photograph of a multitude of identical and usually totally uninteresting objects should be superior to a picture of a single one. Actually, the more perfect the pattern, the more mechanical and boring the effect. More on this on pp. 126–129.

On the other hand, there are three rules concerning the cropping of photographs to which, so far, I have never found an exception. These will be discussed later in the chapter on cropping (p. 69).

The nature of composition is organization; its purpose, to emphasize the subject and present it in the graphically most effective form. This, of course, presupposes an ability on the part of the photographer to see reality in graphic terms. Edward Weston once said that good composition was merely the strongest way of seeing things. Personally, I start composing the moment I conceive the idea for a picture, my main concern being with its organization. How can I introduce order into the natural chaos of my surroundings, where everything acts upon and interferes with everything else, where objects overlap and merge and vie with one another for the observer's attention, where a riot of color and form confronts and confuses the spectator? How can I separate the essential from the superfluous, the meaningful from the meaningless, the beautiful from the ugly? How can I isolate my subject, simplify my picture, and present what I see and feel in the graphically most telling form?

There are many effective ways of graphically separating the important from the superfluous, of visually lifting a subject out of a confusing setting

20

and freeing it from distracting influences, of "editing" the picture before it is made, but all of them rest on two basic assumptions: a total subject approach, and the ability to see reality in photographic terms.

A total subject approach

Unlike photo-technique (focusing the camera, exposing, developing, and printing), the different operations of which follow one another in an orderly sequence and can therefore be considered separately one at a time, *composition is NOT a step-by-step procedure.* Instead, when composing, a photographer must use what I call a "total subject approach" and give *simultaneous* consideration to *all* the different aspects of his future picture because they are inseparably related; a change in one will invariably result in a change in one or more of the others. Here is a typical example:

When considering his camera position (the starting point of any composition), a photographer, having studied his subject from different angles and viewpoints, cannot simply decide, "I like this angle best," and proceed to make the picture. This particular angle might indeed show the subject itself to best advantage, but this may not necessarily be true of all the other components of the scene. What about the background? Is it suitable, or does it contain features such as telephone wires and utility poles that are likely to spoil the beauty of the future picture? Or is the background so similar to the subject in color or tone that the two will visually merge in the rendition? Does it contain patches of bright color or glaring white that, because of distance, appear innocuous in reality but will ruin the picture? Is there an obtrusive pattern-effect (often caused by light and shadow) that might detract from the subject? Is there a light-source or glaring reflection that might manifest itself in the picture as flare? And what about the direction of incident light? Is it satisfactory in regard to the distribution of light and shadow, texture rendition, creation of a feeling of depth? Or is it perhaps too flat — frontlight — or too contrasty — backlight?

Considerations like these make it imperative that a photographer, while studying his subject from various angles and viewpoints, must at the same time pay attention to *all* the other factors that contribute to the effect of his picture: background and foreground; distribution and direction of the light; location and extent of the shadows; color; contrast range; texture; perspective (and perspective distortion); juxtaposition and overlapping of forms, and so on. No matter how right the subject may look from a certain camera

position, unless all the other compositionally important picture elements appear satisfactory, too, the photograph cannot possibly become an unqualified success.

When, later in the book, I go into the various aspects of composition one at a time, it must therefore be understood that such an arrangement was chosen for practical reasons only. It is obviously impossible to talk intelligently about several different subjects at once. Similarly, the order in which these chapters follow one another is mainly one of convenience and does not imply any value. As far as the effect of the picture is concerned, aspects of composition discussed toward the end of the book are no less important than those discussed at the beginning. For a start, the following list groups together those aspects of composition that are particularly closely related and may even overlap, although they will here be treated separately in the interest of clarity of presentation:

- Camera position — angle of view — subject distance — scale of rendition — perspective — background — foreground — direction of the incident light.
- Background — foreground — horizon.
- Picture proportions — cropping — horizontal or vertical composition.
- Static composition — central composition — symmetry — horizon — horizontal and vertical lines.
- Dynamic composition — asymmetry — diagonal lines.
- Framing — foreground.

The ability to see reality in photographic terms

In the course of his development, any serious student of photography will sooner or later discover that a beautiful subject does not necessarily guarantee a beautiful picture. A spectacular landscape turns out puny and trite, a gigantic sequoia lacks scale and looks like any other tree, a colorful sunset sky appears monotonous in black-and-white, a subject characterized by depth looks flat. . . . What happened?

What happened was that the photographer forgot to make allowance for the fact that the eye and the camera "see" things differently, that there is a fundamental difference between the image of a subject as seen by the eye in reality and the image of the same subject rendered in the form of a photo-

22

graph. This, of course, should not come as a surprise if one considers that reality is three-dimensional whereas a photograph has only two dimensions — *depth is missing*. Furthermore, movement is the essence of life, whereas a photograph is a "still" — *motion is missing*. And finally, if we work in black-and-white, *color is missing* and replaced by relatively monotonous shades of gray.

How can one take away three of a subject's most important qualities — depth, motion, and color — and still expect the picture to represent the essence of the original? Obviously, the familiar saying that the camera does not lie, although superficially true, is a fallacy, a fact proven by countless photographs that "didn't come off" although they were sharp, correctly exposed, and properly developed and printed. Despite their technical excellence, they "missed the point" and gave little or nothing of those subject qualities for the sake of which the photographer had taken the picture: life, action, motion, grandeur, mood, the exhilaration of color, the feeling of space and depth. To express photographically these and other intangible qualities, a photographer must present those qualities that cannot be shown directly in picture form by means of graphic symbols (for instance, the feeling of depth expressed by the apparent converging of actually parallel lines), which in turn requires that he be able to see reality in photographic terms. Prerequisite for adept use of such symbols is an awareness of the differences in "seeing" between the eye and the camera.

The eye and the camera "see" things differently for three main reasons:

1. The eye, subordinate to the control center of the brain, sees subjectively, *i.e.*, it is selective insofar as it pays attention only to those aspects of reality that are of immediate interest to the viewer, disregarding the rest. In contrast, the camera "sees" objectively, impartially rendering in picture form important aspects of the subject together with unimportant and distressing ones.

As a result, many photographs are overloaded with superfluous detail, which partly or entirely obscures important qualities of the subject, the qualities for the sake of which the picture was made. Or the photographer, paying attention only to the immediate subject, ignored secondary objects or features (like the proverbial branch behind the girl which in the picture appears to sprout right out of the lovely lady's head, or a glaring light source in the background which subsequently becomes the cause of flare), thereby spoiling his picture. Calamities like these can only be avoided if a photo-

23

grapher trains himself to see *consciously* every part of a scene, from the subject proper down to the lowliest detail in the background, to analyze their possible effects (good and bad) upon the picture, and to correct or eliminate those features he considers undesirable. It is this kind of editing his pictures *before* he takes them that distinguishes the pro from the amateur, and it was with this in mind that Edward Weston always spoke of "making" a picture instead of "taking" it.

2. Human vision is binocular and stereoscopic whereas the "vision" of the camera is monocular. As a result, where the photographer experiences a feeling of depth, the camera registers flatness, unless the photographer knows how to compensate for this shortcoming of the photographic medium by creating in his picture the illusion of depth with the aid of graphic symbols of depth. Convergence of actually parallel lines, foreshortening, diminution, overlapping of objects located at different distances in depth, light and shadow, aerial perspective, all are depth-suggesting devices in the absence of which even a technically perfect photograph will look flat.

3. A photographer experiences a potential subject in the context of its surroundings, relating the part to the whole. In reality, no sharp boundaries exist between the object on which he focuses his attention and objects that are outside his field of view, peripheral vision creating a gradual zone of transition.

In contrast, a photograph shows the subject taken out of context, cut off by the edges of the paper or projection screen, squeezed into the artificial boundaries of a "frame." Since its scale is usually small, it can be taken in at a single glance. As a result, each component of the picture is seen in relation to all the others, forming a design. If the design is weak or confusing, the picture fails. And a subject that was attractive in reality, because its surroundings gave it a special quality or mood, is bound to be disappointing in picture form if it is dissociated from those elements.

Furthermore, the impression made by a subject is not merely a visual one, but is complemented and reinforced by other sensory impressions. When we walk along a beach, for example, in addition to *seeing* the sea, the sand, and the sky, we *hear* the shouts of children and the sound of breaking waves; we *feel* the pounding of the surf, the heat of the sun, and the coolness of the gentle breeze; we *smell* the kelp and we *taste* the salty spray. But when we try to record this overall impression on film, all we can get down is the visual part — and even that without the color if we work in

black-and-white. No wonder so many photographs turn out so disappointing. If anything, the opposite should be true: It is a wonder that a photograph ✷ can convey impressions and feelings at all!

How to see reality in photographic terms

In trying to understand the actions of another person, we are often advised to "put ourselves in his shoes." In trying to understand the working of the camera, we have, likewise, to learn how to "put ourselves behind the lens." An extremely useful gadget for doing just this is the viewing frame.

A viewing frame is an 8″ × 10″ piece of cardboard with a 4″ × 5″ opening through which a photographer can observe his contemplated subject. This has the following advantages:

1. The cardboard acts as a shield, which separates the subject from its surroundings. This enables the photographer to study the subject, evaluate it "out of context" (see p. 24) with the rest of reality, and see it as an independent, self-contained unit — the way it would eventually appear in picture form.

2. By viewing the subject through the opening with only one eye (keeping the other one shut), the photographer transforms his normally stereoscopic vision into monocular vision. This enables him to see the world as the lens "sees" it, *i.e.*, flat, without depth. Shutting one eye is a strong reminder that the third dimension cannot be rendered directly in the two-dimensional plane of the picture. Of course, the *illusion* of depth can be created with the aid of symbolic depth-suggesting graphic means, primarily ✷ the apparent converging of actually parallel lines, overlapping of forms, foreshortening, diminution, and aerial perspective.

3. By studying his subject through the viewing frame held at different distances from the eye — now close, now farther away — the photographer can simulate the effects that would result if pictures were taken with lenses of different focal lengths. The frame held close to the eye imitates the effect of a wide-angle lens; the frame at normal distance shows how the picture would look if taken with a lens of standard focal length; and the frame held at arm's length indicates the effect of a telephoto lens.

4. Use of a viewing frame enables a photographer not only to preselect the lens with the most suitable focal length (and thereby decide the scale of rendition), but also to predetermine the most effective boundaries of his future picture. By gradually shifting his viewing frame laterally and vertically, he can study his subject with any imaginable kind of "cropping" (see p. 66). By rotating the frame 90 degrees, he can decide whether a horizontal or a vertical composition (p. 49) would suit the subject best.

5. By looking at architectural subjects through the frame held strictly at a right angle to the axis of seeing, a photographer can consciously observe the apparent converging of actually parallel, vertical lines in "angle shots," since the parallel edges of the viewing device provide the necessary frame of reference. This is a valuable lesson in seeing things as they really are instead of seeing them as we think they ought to be — a trick played on us by memory and convention. (We know that vertical lines are parallel, so how could they converge?)

In regard to color rendition, photographers must realize that the eye is a first-class deceiver when it comes to evaluating color in photographic terms. It is, for example, a notoriously unreliable instrument for gauging the color of incident light, because it quickly and automatically adapts to minor (and under certain conditions not so minor) changes, pronouncing the light "white" even though it may be distinctly colored. In contrast, color film is very sensitive to even minute deviations from standard in the color of the light for which it is balanced, invariably reacting with a corresponding color cast. As a result, "natural"-appearing color rendition can only be expected if color film is used in conjunction with the type of light for which it is intended. Since color film is made in only three different types for use with four different kinds of light (one for standard daylight and electronic flash and one each for 3400 K photoflood lamps and 3200 K professional tungsten lamps), color pictures taken in other kinds of light (particularly non-standard daylight) are bound to appear "unnatural" in color rendition, unless the photographer knows how to convert light of the "wrong" color into light of the kind for which his color film is balanced. This he can do easily with the aid of light-balancing filters by following the instructions given in any book on color photography. But before a photographer can apply color-correction filters effectively, he must learn from published data, practical experience, and actual tests how to gauge the "true" color of the incident light. He cannot rely on his eyes.

On other occasions, the eye can deceive a photographer by making color appear more beautiful than it actually is. This is most likely to happen in cases where a multitude of small patches of color is scattered over a large area, e.g., an overall shot of a garden full of flowers, or if many different colors occur within the same scene. Although bright and gay in reality, in picture form such subjects will always appear either disappointingly ineffective or gaudy and "cheap."

Similarly disappointing results may occur in black-and-white photography, where strong subject coloration can mislead a photographer to risk a shot, especially if the translation of subject color into shades of gray is not controlled with the aid of filters (for reasons that will be explained in a moment). Experienced photographers know that subjects whose outstanding quality is color make notoriously unsatisfactory black-and-white photographs. Either avoid them or take them in color.

In black-and-white photography, colors are transformed into corresponding shades of gray. Although this transformation occurs automatically every time we take a picture, it can and should be controlled by the photographer. This control is an indispensable means for creating effective black-and-white photographs, because it enables a photographer to "symbolize" color by contrast. The necessity for this should be obvious if one considers the following:

In black-and-white photography, colors of different hues (for example, green, red, and blue) but similar or identical brightness (for example, medium-light color shades) will be rendered as similar or identical shades of gray, merging more or less completely in the picture with the result that graphic separation between the objects that they represent is lost. To avoid this decidedly undesirable possibility, the photographer can control color rendition and thereby improve or restore graphic separation within the picture with the aid of color filters. A filter for black-and-white photography always renders its own or any closely related color as a lighter shade of gray and its complementary or near-complementary colors darker than they would have appeared in the picture if no filter had been used. You can observe this effect for yourself by looking at the subject through the respective filter. Although the scene will appear as a monochrome in the color of the filter, colors that would be rendered in the picture as lighter shades of gray also appear lighter to the eye, and colors that would be rendered darker appear darker. Failure to use the appropriate color filter is the most common reason why in black-and-white photographs colorful subjects appear disappointing, contrastless, and flat — proof positive that the photographer was unable to see and evaluate color in photographic terms.

In regard to motion rendition, photographers must realize that movement, like depth (or color in black-and-white photography), cannot be rendered directly in a still photograph, but only indirectly in symbolic form. Normally, the most effective symbol is blur: The more blurred the image of the moving subject in the picture, the faster the subject seems to have moved in reality. Awareness of the necessity for a symbolic treatment of motion in a photograph and familiarity with the graphic symbols of motion are important, because indiscriminate freezing of motion by means of high shutter speeds or flash may actually negate the purpose of the picture. In automobile racing, for example, speed is the most important factor, but the sharp picture of the competing cars frozen at very high speeds would be in no way different from a photograph showing the same cars standing still.

Complete information on all the means for graphically symbolizing depth, color, and motion can be found in my other books, *The Complete Photographer* and *The Color Photo Book*, both published by Prentice-Hall, and *Total Picture Control*, published by Amphoto.

IV. The Principles of Composition

By now it should be obvious that although there are no specific rules of composition, certain principles exist by which a photographer can let himself be guided. Such principles derive from the realization that composing means "giving form by putting together." This involves clarifying, emphasizing, condensing, isolating, adding, taking away, rearranging, improving, selecting, and rejecting ideas, concepts, aspects of the subject, and components of the picture on the basis of choice. This is a process that can be summed up in three words:

Exploration
Isolation
Organization

EXPLORATION

Having made up his mind to photograph a certain subject, a photographer should first explore it in depth. Rarely if ever is the first view the most effective one. More likely, it is also the most obvious one, the kind of view that other photographers have "done" successfully before — and merely repeating somebody else's work gives very little satisfaction.

Ideally, exploring a subject in depth means looking at it from all sides — front, back, right, left, above, below. It also means studying it in relation to its surroundings — primarily, of course, its background, of which I spoke already and will have to say more later — and to all the other factors that might influence its appearance in picture form. The most important is the nature and direction of the incident light.

The same subject can make a very different impression depending on whether it is seen in *direct light* (sunlight, spotlight, photoflood, flash) or *diffused light* (outdoors, in the open shade or under an overcast sky; indoors, by reflected light, for example, bounce flash); and on whether it is illuminated by *frontlight, sidelight, backlight,* or *light from above.* In this respect, a photographer should consider the following:

Direct light is always relatively harsh and contrasty, casts strong and sharply defined shadows and, in portraiture, is likely to make people squint and squirm. It is a "plastic" type of light, well suited to modelling the forms of the subject, emphasizing surface texture, and creating in the picture illusions of three-dimensionality and depth.

Diffused light is relatively soft insofar as the contrast between light and shadow is low, and the outlines of the shadows are vague. In totally diffused light (for example, if the subject is surrounded by a light-tent), no shadows are cast at all. Diffused light is particularly suitable in portraiture and in all cases in which an unusually detailed rendition of the subject is required, for in direct light detail is often lost in the shadows.

Frontlight — light-source behind the photographer when he faces the subject — casts very few or no (ringlight electronic flash) visible shadows and is therefore apt to make the subject appear flat. It does not create illusions of depth. However, it is the type of light that is most suitable to perfect color rendition.

Sidelight — light-source more or less to one side of the photographer when he faces the subject — casts well-defined shadows and makes objects appear three-dimensional in the picture. In photography, it is the most often used type of light, seldom wrong, but not likely to lead to particularly unusual or interesting effects.

Backlight — light-source more or less in front of the photographer when he faces the subject — is the most contrasty of all the different types of light, since the side of the subject that faces the camera is mainly or totally in the shade, yet surrounded by very strong light. It is the type of light most difficult to handle successfully (particularly in color photography because the contrast range of color film is much more limited than that of black-and-white film), but, in the hands of an expert, the potentially most effective type of light. Where possible, when working with backlight, the photographer should normally take care to prevent direct light from striking the lens, because this might lead to flare and halation in the picture.

Light from above — the typical high-noon light in summer — is pictorially the least effective type of light. Whereas amateurs like to take their pictures during the middle of the day, because then the light is nice and bright, experienced photographers know that the best times for outdoor

photography are the morning and afternoon hours when the sun is relatively low in the sky.

Basically, exploration of the subject can proceed under one of three conditions:

The camera can move, the subject is stationary;
the camera is stationary, the subject moves;
both the camera and the subject can move.

The camera can move, the subject is stationary

This situation is familiar to any photographer from landscape and architectural photography but applies, of course, to all normally immovable objects — statues and monuments, rock formations, trees, and so forth. To insure a well-composed picture, a photographer must pay particular attention to two important aspects:

The relationship between subject, foreground, and background is one of the most important visual factors that affect the impression of the picture. What good is it to show the subject from the most effective angle if it blends with the background (*e.g.*, a dark statue against a backdrop of trees), has to compete with ugly background matter (telephone wires or power lines crossing the sky, a wire fence), or is seen across messy shrubbery, parked cars that do not relate to the subject, or a stretch of empty pavement, to name only a few of the most commonly made mistakes?

Faults like these can often be avoided by making practical use of the concept of parallax: the shift in the apparent position of the subject relative to its foreground or background as the result of a change in the position of the camera. Frequently, all that is needed to relegate an undesirable background feature to a location outside the field of view of the lens is to move the camera a few feet to one side or the other, or to shoot from a lower position to show the subject more against the sky.

If this is inadequate, impractical, or impossible, a change in subject distance in conjunction with use of a lens of a different focal length may bring about the desired result. By stepping back and making the shot with a telephoto lens, a photographer can often eliminate empty foreground as well as undesirable features in the background. Conversely, by going closer and

(Text continued on p. 34)

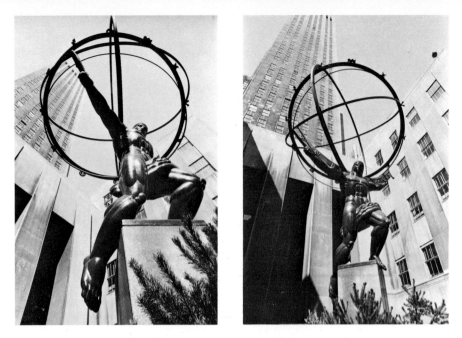

Atlas, Rockefeller Center, New York, by John Veltri. To get the full benefit from Veltri's pictures, it is important that the reader study each shot in detail, paying particular attention to the relationship between the sculpture and its surroundings, the angle of view, the perspective (and possible distortion), the background, the

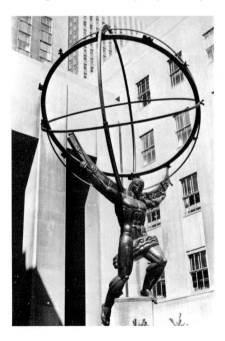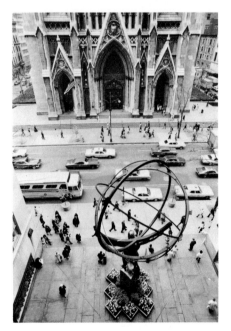

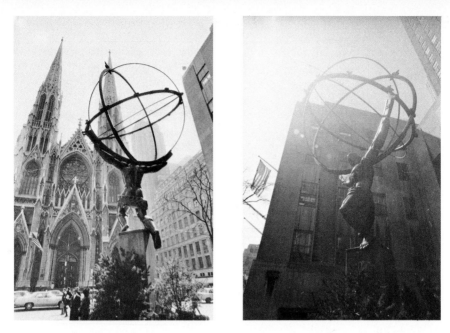

distribution of light and shadow (and the resulting arrangement in terms of black-and-white), and the direction of the light and its effect upon subject and background. Then he should decide which of the different versions he likes best, which he likes least, and clarify in his mind the reasons for his likes and dislikes.

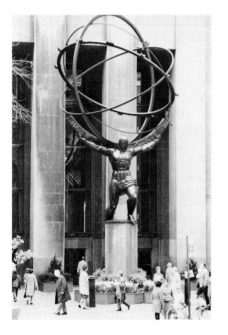

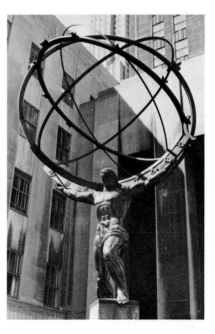

taking the picture with a wide-angle lens, pretty much the same result can be achieved, although the perspectives of the two pictures would be very different. In the first case, space would appear less deep, more compressed, and the actual proportions between the subject and its surroundings would be more or less preserved. In the latter case, depth would appear enlarged, because near objects would be rendered abnormally large and far objects abnormally small. Whether or not such wide-angle distortion is pictorially desirable must, of course, be carefully considered in each case. Depending on the circumstances (the physical layout, the nature of the subject, and the purpose of the picture), wide-angle distortion can be an asset or a fault.

A third method by means of which a photographer can suppress (and sometimes eliminate) undesirable features of the background or foreground is the technique called "selective focus": Instead of stopping down the lens as far as possible, he stops it down only as far as necessary to render the subject proper sharp, but *not* the background or foreground. The difference between the sharpness of the subject and the unsharpness of the background or foreground will be the greater, the less the lens has to be stopped down, the longer its focal length, the shorter the distance between subject and camera, and the greater the distance between subject and background or foreground.

The direction and character of the incident light is another one of the visually vital factors that affect the impression a picture makes. In this respect, freedom of choice and action on the part of the photographer are much more limited in cases in which the subject is immovable than in those in which it is movable. If the picture has to be made by daylight, all a photographer can do to convert an unsatisfactory illumination to a more effective one is to wait, either for the sun to reach a more suitable position in the sky, or for the atmospheric conditions to change. An example would be waiting until clouds cover the sun and thereby transform direct light casting heavy shadows into diffused, virtually shadowless light.

The accompanying sequence of photographs by John Veltri (p. 32), showing the statue of Atlas in front of one of the buildings of Rockefeller Center in New York, gives an idea of how a creative photographer explores a "simple but difficult" immovable subject in depth. The subject is simple because it is easily accessible, rather small, and can be thoroughly explored within a relatively short time. It is difficult because it represents a rather undistinguished work of sculpture possessing no particular photogenic qualities situated in a crowded, complex, and graphically confusing setting.

34

The camera is stationary, the subject moves

This situation applies particularly when one is photographing a political, sport, or other public event from an assigned camera position, but also in cases in which a photographer picks himself a spot from which to take photographs of unsuspecting people in the manner of *Candid Camera* or when photographing wild animals from a blind. The fact that the photographer is unable to go after his subject and must instead be satisfied with whatever happens imposes, of course, severe limitations on his activity. However, all is not lost. He still can explore his subject extensively and make the best of a difficult situation if he considers the following possibilities:

Advance information on what to expect provides at least a certain measure of insurance against unpleasant surprises and outright failure. Such advance information (which in the case of public events can be obtained from the public relations department of the organizer of the activity) should include a timetable of events, a map showing the general layout and the distances between camera position and the points of action, and the directions of the compass relative to the expected action. Information of this kind provides the basis on which a photographer can make an intelligent equipment selection and also time his shots in such a way that he is not likely to miss an important phase.

Take plenty of film and shoot too much rather than too little — one can never be sure what will happen next. Few things are more agonizing to an ambitious photographer than running out of film before the job is finished, unless it is the realization that he missed important shots because he was trying to economize on film. Professional photographers treat film as a cheap and expendable commodity; they know that it is sheer madness to try and save pennies on film, thereby taking a chance of blowing a once-in-a-lifetime opportunity or a thousand-dollar assignment. And they shoot roll after roll of film, *not* because they hope, like many amateurs, that if only they take a sufficiently large number of pictures, according to the laws of chance at least some should "turn out alright," *but* because they realize that the picture they passed up as not interesting enough may subsequently prove to have been the most important shot — perhaps because right afterwards the sun disappeared, or it started to rain, or the camera broke down, or simply because what followed was less interesting.

A set of interchangeable lenses assures mastery of distance and space. Should it become desirable to render the subject in larger scale, instead of

moving closer with the camera, which, according to our assumptions, is impossible, image size can still be increased to virtually any desired degree by use of a telephoto lens of appropriate focal length. Conversely, although the photographer cannot back away from his subject in order to include more of its surroundings in the picture, he can still achieve this goal by making the shot with a wide-angle lens.

Pay attention to the background. Although a photographer may be unable to avoid unsuitable background matter by changing his camera position, he still can wait until the moving subject appears in front of a more suitable background. Furthermore, if, for reasons explained above, he is forced to work with telephoto lenses, he should remember that this type of lens, if used at more or less full aperture, has a shallow depth of field. Utilization of this characteristic will throw the background out of focus. This not only minimizes the pictorial damage of an objectionable background, but also emphasizes the subject graphically through sharpness and at the same time plays down extraneous picture elements through unsharp rendition. If the photographer works in black-and-white, he must not forget to translate color contrast into black-and-white contrast, if necessary with the aid of filters.

Both the camera and the subject can move

This is the most common situation; it is also the easiest and at the same time the most difficult one: the easiest — because the possibilities for subject exploration are unlimited, or rather, limited only by the resourcefulness, imagination, and endurance of the photographer; the most difficult — because anything may happen, from the most wonderful surprise to a disaster, at the next corner, within the next hour, or within seconds. A beautiful girl emerging from a crowd, a marvelous gesture, a smile on a lovely face, a split-second configuration of people in the street with each person in just the right position (Henry Cartier-Bresson's *Decisive Moment!*) — such photographic opportunities appear as suddenly as they are gone, and unless a photographer is ready, he may strike out and never get another chance again. To cope with such situations, which often yield the most beautiful, unusual, and interesting pictures, he must be properly prepared, both in equipment and in mental alertness.

Preparedness for dealing successfully with sudden and unexpected events consists in having the right equipment in the right condition and being constantly on the alert. The best camera for grab-shooting is a 35mm (or 18 ×

36

24mm) single-lens reflex or rangefinder camera equipped with a lens of relatively short focal length (40 to 45mm in the case of a 35mm camera) loaded with a fast black-and-white or color film. The short focal length provides a safety margin of sharpness in depth and thereby makes precise, time-consuming focusing unnecessary; the fast film permits the use of relatively high shutter speeds suitable to stopping subject motion and simultaneously minimizing the danger of unwanted blur due to accidental camera movement during the exposure. To make the most of these advantages, knowledgeable photographers set their camera controls in advance in accordance with the following table:

Camera settings for medium distances				Camera settings for hyperfocal distances		
f/stop	Focus at	Depth of field	Film size and focal length	f/stop	Focus at	Depth of field
f/8	10'	8'-13'	35mm	f/8	30'	15'-∞
f/11	15'	10'-30'	F/2"	f/11	20'	10'-∞
f/8	10'	8½'-15'	2¼ x 2¼"	f/8	32'	16'-∞
f/11	15'	11'-32'	F/3¼"	f/11	22'	11'-∞
f/8	10'	10'-15'	2¼ x 3¼"	f/8	46'	23'-∞
f/11	15'	12'-20'	F/4½"	f/11	34'	17'-∞

Now, if the shutter speed has also been preset in accordance with the film speed rating and the brightness of the ambient light, should something interesting turn up, all a photographer has to do is to raise the camera, aim, and shoot, secure in the knowledge that focus and exposure will be correct.

Other important factors. That many of the aspects already discussed on pp. 29–36 apply also to the type of situation treated here goes, of course, without saying. Particularly, a photographer should pay attention to the background, the type and direction of the light, and if he works in black-and-white, the color values of his subject. Although the speed with which things happen may severely restrict his freedom of action in these respects, and he furthermore may decide that an imperfect picture is better than no picture at all, awareness of these factors will often enable him to turn an apparently impossible situation into a tolerable one. Still better results will, of course, be achieved by photographers who are sufficiently knowledgeable to recognize a hopeless situation when they see it and sufficiently disciplined to pass it up in favor of a more promising one.

ISOLATION

Having visually explored the subject in its totality (including its relation-ship to foreground and background, its contrast and coloring, perspective and possible distortion, the type and direction of the ambient light) and come to a decision in regard to the form in which he would like to render it, a photographer should then proceed to isolate the subject and eliminate extraneous pictorial influences as a prerequisite for presenting it in the graphically most effective form.

Now I can hear some readers grumble: "All this is very well and I couldn't agree more, but what does it have to do with composition? I always was under the impression that composition had to do with arrangement and relationships, but not with such elementary concepts as subject isolation." Wrong — because, as I said before, composition is *not* just one specific step in the process of picture-making; to be meaningful, it must pervade the en-tire thinking of a photographer. As a result, compositional considerations are likely to crop up at any time from the moment a picture is conceived, and subject isolation is one of them. Unless a photographer first defines his subject in pictorial terms and isolates it graphically, he has nothing to compose.

Not even a photographic genius can make a well-composed picture out of pictorial hash. Remember Edward Weston's definition of composition as merely the strongest way of seeing things — and the strongest is always the most direct, the simplest, the most condensed, and pictorially least diluted way. Even if a subject is as big as an entire landscape, a photographer will find that condensing his view (perhaps with the aid of a telephoto lens) and composing it around a central motif (perhaps a group of trees, a rock forma-tion, a grain elevator, or the white church in the valley) will strengthen the impact of his picture. Let me repeat, for emphasis: Composing is synony-mous with organizing; regardless of the nature of the subject, composing should start the moment a photographer decides to make a picture.

There are many effective ways in which a photographer can isolate his subject, separate the important from the superfluous, visually lift the subject out of a confusing setting, and free it from pictorially undesirable influences. This kind of editing can take many forms. Since most of these involve the application of elementary photo-techniques that are probably familiar to the reader, I list them here only briefly as an aid to memory and refer those who wish to know more about them to my other books, *The Complete Photo-grapher* and *The Color Photo Book,* both published by Prentice-Hall, where they are fully discussed.

38

1. If the subject is relatively near (a person, a face), the simplest way of editing the picture before it is made is usually to rearrange an unsatisfactory scene and physically remove distracting objects, like a painting on a wall in the background, a table lamp, a potted plant.

2. If rearranging the scene is too time-consuming or too difficult and the subject can be moved, the solution is simply to find a better setting in which to photograph it. Should this be impractical, too, abstaining from making the photograph is, in my opinion, preferable to making a bad picture.

3. One of the simplest, most effective, and usually feasible ways of excluding pictorially extraneous matter is to have the subject proper fill most or all of the picture. This can be done in one of two ways: either by means of a close-up (moving in sufficiently close with the camera), or by using a telephoto lens of appropriate focal length. Although, at first, the results of these techniques may seem identical, this is not the case. The differences, which are subtle but important, are illustrated in the series of photographs on pp. 40–41.

Conclusion. Changes in the distance between subject and camera produce changes not only in the scale of the subject, but also in the perspective of the picture and the relationship between subject (foreground) and background.

Conclusion. Taking pictures from the same camera position with lenses of different focal lengths produces changes in the scale of the rendition and in the included angle of view but does *not* produce changes in the perspective of the picture or in the relationship between subject (foreground) and background.

Conclusion. Virtually the same effect — squeezing out extraneous subject matter and increasing the scale of rendition of the subject proper until it fills most or all of the picture space — can be accomplished in one of two ways: by decreasing the subject-to-camera distance; or by taking the picture with a lens of longer focal length (known as a telephoto lens). But the compositional differences that manifest themselves in corresponding differences in the perspective of the picture (relationship and scale of foreground to background) can be considerable.

4. The subject can be isolated, the effect of undesirable pictorial matter in the background (or foreground) can be minimized, and graphic separation

(Text continued on p. 42)

All the pictures in the top row were shot with the same lens, of standard focal length. The differences in scale are due to differences in subject-to-camera distance: the shorter the distance, the larger the scale of rendition. However, the background, which was so far away that changing the subject distance did not affect its rendition noticeably, appears in all four pictures in virtually the same size.

All the pictures in the bottom row were shot from the identical camera position with lenses of increasingly longer focal lengths, from left to right. The longer the focal length, the larger the scale of rendition. Notice that the relative positions of subject and background remain the same in all four pictures (which was not the case in the first series of shots), and that the scale of the background increases at the same rate as that of the subject.

You have a choice: overall sharpness (left) or selective focus (right).

between the subject proper and the background and foreground (if apparent in the picture) can be improved, through the technique of selective focus. This means carefully (selectively) focusing on the subject proper, then making the picture with the diaphragm stopped down *as little as possible* (instead of as much as possible — the normal procedure designed to create a maximum of sharpness in depth), just enough to insure that the subject itself will be rendered sharp. As a result, detail of the background (and foreground, if apparent in the picture) will be suppressed by unsharpness, whereas the subject will stand out in splendid isolation, prominent and sharp. This effect is the more pronounced the larger the diaphragm aperture, the longer the focal length of the lens, and the shorter the distance between subject and camera.

5. Under certain conditions, the subject can be isolated by means of light: Illuminate the subject, but keep the background in the shade. If artificial light is used, adjusting the lamps accordingly, or interposing suitable panels between background and lamps, will produce the desired effect. Out-

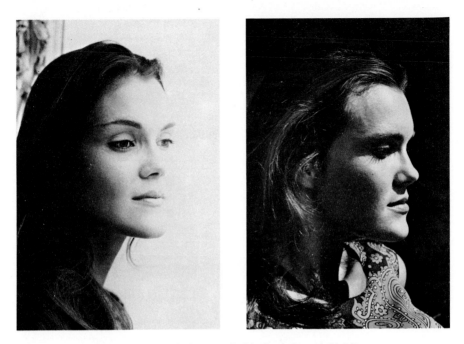

You have a choice: unsuitable (left) or suitable background (right).

doors, it is sometimes possible to achieve the same effect by taking the picture at the moment when the shadow of a passing cloud darkens the background while the subject is fully illuminated by the sun. An application of this technique is shown in the photographs above.

6. Outdoors, in certain cases, taking the picture from a relatively low angle — camera held close to the ground and tilted upward — enables the photographer to exchange a messy background for the clean and unobtrusive sky. This is yet another way of effectively isolating the subject and getting rid of pictorially distracting detail.

7. In black-and-white photography, provided that subject and background possess more or less complementary colors, subject isolation can be accomplished with the aid of color filters: Using a filter in the color of the subject will cause its color to appear in the picture as a lighter shade of gray, and the complementary color of the background as a darker shade, as they would have appeared if no filter had been used. In this way, complementary

43

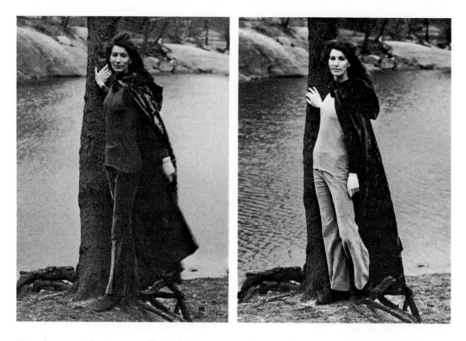

You have a choice: no filter (left) or red filter (right); note difference in tonal separation.

(or near complementary) colors of equal (or nearly equal) brightness, like a medium-red and medium-green, can effectively be separated in a black-and-white photograph instead of being rendered as two more or less identical, merging shades of gray. This technique is illustrated by the pictures above.

Summing up

A number of effective techniques for isolating the subject and suppressing or eliminating unwanted detail are at the disposal of any photographer willing to take the trouble to avail himself of them. The diversity of these techniques assures that at least one will fit any given case, no matter how bizarre. The most powerful effects are, of course, achieved if two or more of these techniques are used simultaneously in the same picture.

44

ORGANIZATION

The essence of composition is organization. Organization implies order. And order means logical arrangement, with every subject component, every picture element in its proper place. What is its proper place? The place where it does the most good, appears to best advantage, is in harmony with the rest. A good composition is a harmonious composition, a visual accord. And as a beautiful accord in music gives pleasure to the ear, so a harmonious composition gives pleasure to the eye. Conversely, a poor or disharmonious composition strikes a sour note, in music as well as in photography.

I realize that right here I might get severe static from a lot of photographers who might object: "But what about photographs of a riot, or a slum, or cholera victims in Pakistan, dead soldiers in Vietnam — should they also be well composed so that they can give pleasure to the eye? How can such pictures give pleasure to anybody? Shouldn't they deliberately strike a sour note, evoke outrage, horror, protest, provide an appeal to all decent people to do something positive and correct such inhuman conditions?"

Such objections, understandable as they are, miss the point. Of course, photographs depicting human misery in whatever form should strike a sour note in the mind of the beholder, but *not* because of poor composition. Actually, the better the composition, *i.e.*, the simpler, bolder, more to the point, the stronger the impact of the picture. On the other hand, the weaker the composition (for instance, the more diluted with extraneous subject matter), the weaker the effect. But the graphic compositional effect of a picture is one thing, its content or message, another. The first is determined by the artistic ability of the photographer, the second by his attitude toward his subject.

A favorite subject of most tourists traveling in foreign countries, for example, is the "native quarter" of cities and towns: the narrow crooked streets, the alleys, the slums, the beggars young and old, which they find quaint and picturesque. And superficially seen, photographed in backlight with the sun weaving haloes around the old men's beards, texture brought out by carefully chosen illumination, figures interestingly grouped, colors vibrant and gay, such pictures have an undeniable charm. But to any socially aware human being such pictures are visual lies. Behind the facade of sunshine and intriguing unfamiliarity lies a world of poverty and deprivation, of suffering, hunger, and disease, of misery without hope. Really, how many of

(Text continued on p. 48)

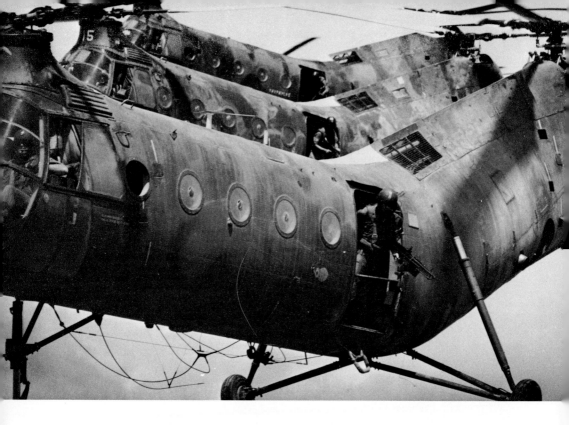

Above, H-21 attack helicopters in Vietnam, by Larry Burrows; opposite page, Fifth Avenue, New York, by Andreas Feininger. Both photographs were made with telephoto lenses, and telephoto lenses, because they produce telephoto perspectives, are among the most valuable tools of composition. For two reasons: 1, because they bring the subject close and thereby avoid diluting it with superfluous surrounding detail. And 2, because they minimize diminution and perspective distortion, *i.e.*, they render the various picture elements in more natural proportions to one another than lenses of standard focal length.

Whereas the "second lens" which an average photographer acquires is usually a wide-angle lens, the second lens of a creative photographer is a telephoto lens. And whereas beginners and average photographers use telephoto lenses only in cases in which the subject is so far away that a lens of standard focal length would render it too small, creative photographers deliberately increase the distance between subject and camera in order to be able to make the shot with a telephoto lens—they know that the result will be a stronger picture.

46

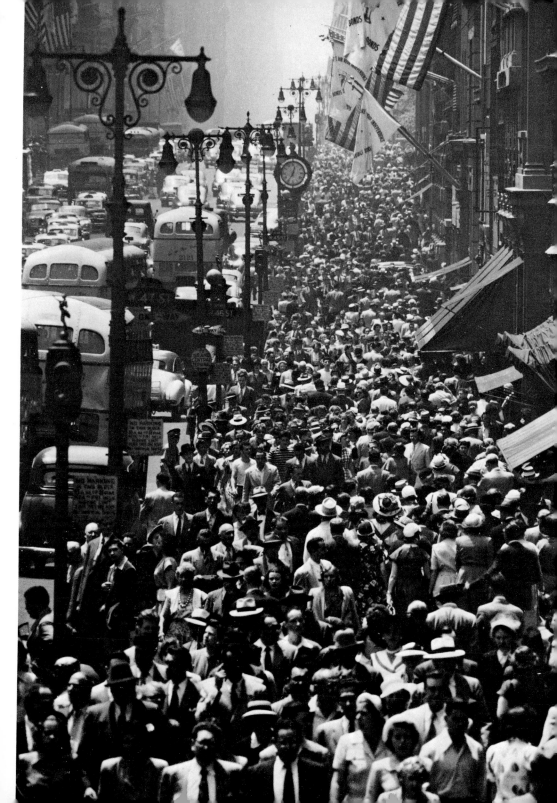

those tourists who depict such scenes with so much skill and dedication would like to live under such conditions? So why pretend, why try to evoke impressions of beauty where feelings of horror and compassion would have been more appropriate?

Such photographers misread the scene. The fault is theirs, not that of composition. They misuse photography, as any invention made by man can be misused, no matter how beneficial its potential. Their whole approach to the subject is wrong, and they disguise their lack of feeling by using the tools of composition to create superficial impressions of beauty.

In contrast, a compassionate photographer's attitude would be to try and tell the world what is really going on, make people take notice, make them think and feel. Great photographs of this kind have been published again and again in *Life* and other magazines. Such pictures indeed strike a sour note, *not* because they are badly composed, but because *this was the intent of the photographer*. And the sour note is evoked not by poor composition, but by the subject — the human misery, the stench of corruption and death. As a matter of fact, most of these photographs are powerful and convincing precisely because they are well-composed, without frills or superficial window-dressing, going straight to the heart of the matter. Close-ups of faces, tightly composed groups, uncompromising documents of suffering humanity. And effective — because of strong composition. Which goes to show that what counts is not what you look at, but how you look at it.

A photograph can be organized in many different ways, depending on the nature of the subject and the intentions of the photographer who reacted in a specific way to what he saw. Some possibilities are: organization based upon the arrangement of lines and forms, or of colors, or upon distribution of light and dark (organization along graphic lines); and organization based upon the relationship of foreground, middleground, and background, or of earth and sky (organization along spatial lines). Simultaneously, a photograph can be organized to create a static impression of order, tranquillity, permanence, peace; or a dynamic impression of action, violence, the drama of life. It can be organized to express motion and the sensation of speed, or other intangible concepts. The means by which these effects can be accomplished will be discussed later.

Although, as pointed out before, composition is neither a one-time nor a step-by-step operation but an attitude that must pervade the entire process of picture-making, when it comes to organizing his future picture, no matter in what way, a photographer must begin somewhere. A natural point of departure is determining the proportions of his transparency or print.

48

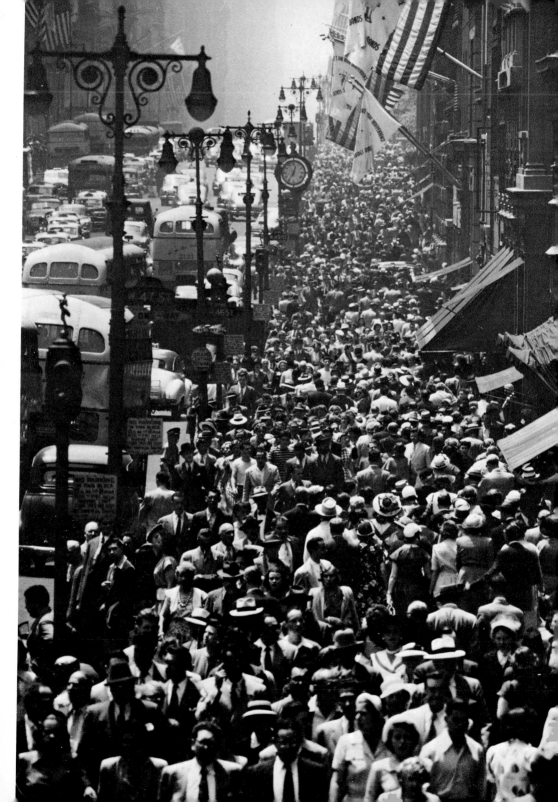

those tourists who depict such scenes with so much skill and dedication would like to live under such conditions? So why pretend, why try to evoke impressions of beauty where feelings of horror and compassion would have been more appropriate?

Such photographers misread the scene. The fault is theirs, not that of composition. They misuse photography, as any invention made by man can be misused, no matter how beneficial its potential. Their whole approach to the subject is wrong, and they disguise their lack of feeling by using the tools of composition to create superficial impressions of beauty.

In contrast, a compassionate photographer's attitude would be to try and tell the world what is really going on, make people take notice, make them think and feel. Great photographs of this kind have been published again and again in *Life* and other magazines. Such pictures indeed strike a sour note, *not* because they are badly composed, but because *this was the intent of the photographer*. And the sour note is evoked not by poor composition, but by the subject — the human misery, the stench of corruption and death. As a matter of fact, most of these photographs are powerful and convincing precisely because they are well-composed, without frills or superficial window-dressing, going straight to the heart of the matter. Close-ups of faces, tightly composed groups, uncompromising documents of suffering humanity. And effective — because of strong composition. Which goes to show that what counts is not what you look at, but how you look at it.

A photograph can be organized in many different ways, depending on the nature of the subject and the intentions of the photographer who reacted in a specific way to what he saw. Some possibilities are: organization based upon the arrangement of lines and forms, or of colors, or upon distribution of light and dark (organization along graphic lines); and organization based upon the relationship of foreground, middleground, and background, or of earth and sky (organization along spatial lines). Simultaneously, a photograph can be organized to create a static impression of order, tranquillity, permanence, peace; or a dynamic impression of action, violence, the drama of life. It can be organized to express motion and the sensation of speed, or other intangible concepts. The means by which these effects can be accomplished will be discussed later.

Although, as pointed out before, composition is neither a one-time nor a step-by-step operation but an attitude that must pervade the entire process of picture-making, when it comes to organizing his future picture, no matter in what way, a photographer must begin somewhere. A natural point of departure is determining the proportions of his transparency or print.

48

John Veltri

The proportions of the picture

A photographer has the choice of giving his pictures one of four basic forms: horizontal rectangle, vertical rectangle, square, and circle. Furthermore, the rectangles can have any proportion from long and slim to square. This choice applies regardless of the format of the camera, for a negative can be cropped during enlarging or a transparency masked to conform to any desired shape. This choice is an important aspect of composition since it directly influences the arrangement and relationship of all the picture components.

The rectangle, in contrast to the square and the circle, because one of its dimensions is longer than the other, implies direction. A horizontal rectangle emphasizes horizontal lines and planes, the horizon, and the directions right and left. A vertical rectangle emphasizes vertical lines and planes, height, spacial extension (depth) away from the photographer, and the directions up and down. The slimmer the rectangle, the more pronounced these characteristics, and vice versa. Hence, by choosing a specific format for his picture, a photographer can give a precisely calculated degree of additional emphasis to certain qualities of his subject.

Andreas Feininger

By choosing the pro-
portions of the print in
accordance with the char-
acter of the subject, a pho-
tographer can emphasize
certain qualities such as
lateral expanse (above),
upward thrust (left), or
placidity (opposite).

John Veltri

The square, because of its biaxial symmetry, is center-directed and tensionless. It is a static picture form and suggests concepts of stability, power, permanence, and rest. It is also rather dull — but then, dullness, which is closely related to peace and tranquillity, is a common quality of many photographic subjects. Should it be desirable to express such qualities in picture form, the square would be the logical choice.

Because the square format obviates the need to turn the camera on its side when one is switching from a horizontal to a vertical picture or vice

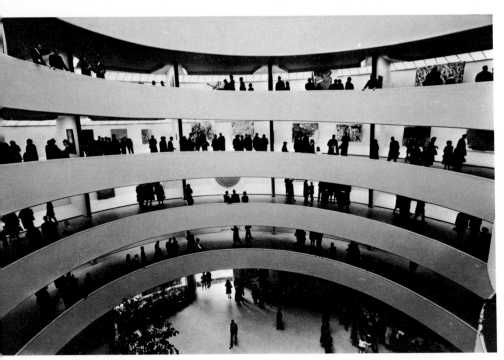

Andreas Feininger

Guggenheim Museum, New York. Two versions of the same subject, illustrating different attitudes. Neither picture is better than the other, although they are different. Which one do YOU prefer: the elongated view made with a panoramic camera (above) or the circular view made with a fish-eye lens (opposite)?

versa — which, in the case of single-lens and twin-lens reflex cameras with waistlevel viewfinders, is horribly inconvenient and in practice almost impossible — all such cameras are designed to take square pictures. The only exceptions are those few that are equipped with revolving backs and produce 2¼″ × 2¾″ negatives. Photographers working with square-format cameras, deprived of the opportunity to evaluate visually the differences between horizontal and vertical views, usually develop a tendency to compose all their pictures in such a way that the subject entirely fills the square format. This, of course, leads to stereotyped pictures. Photographers finding themselves so disposed should make a serious effort to correct this weakness, *i.e.*, compose their pictures in accordance with the requirements of the subject, even if this means wasting part of the negative through cropping during enlarging or masking a color transparency.

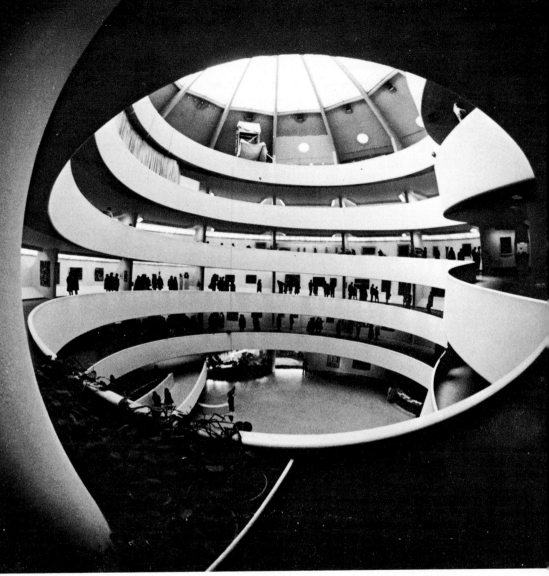

The circle, a picture form not uncommon during the last century but subsequently forgotten, has recently been resurrected because fish-eye lenses produce circular pictures. This picture form is even more center-directed than the square, a fact which makes it eminently suitable to the peculiar "spherical perspective" typical of fish-eye lenses, but virtually useless in all other cases.

Practical considerations. Having made up his mind which format to give his future picture, a photographer should next select the distance from his subject, or the focal length of his lens (see pp. 31–34), in such a way that the subject almost, *but not quite*, fills the frame of the picture. In other words, he should leave a narrow safety margin around the subject proper which will later give him a chance to make final compositional adjustments during enlarging. It is always possible to eliminate superfluous marginal subject matter through cropping, but finding that an essential part of the scene is missing in the negative is tantamount to pictorial disaster.

For the same reason, whenever circumstances permit, I make it a rule to take not one, but several shots of my subject, each slightly different in the way it is framed. This is analogous to the practice of bracketing as a means of insuring a perfect exposure, except that in this case the motivation is pictorial instead of technical. But I am a great believer in the motto that if a subject is worth photographing at all, it is worth photographing well, which implies that the photographer must not overlook a single aspect that might contribute to his success.

Author's Note. What makes writing a book on composition so difficult is the fact that, at least in my experience, there are no definite rules, no DO's, no DON'T's, as there are in photo-technique. There, correct exposure is the predictable result of using an exposure meter in the prescribed manner, normal film development takes so-and-so many minutes at such-and-such a temperature, color is either true to the original or not. Here, everything is a matter of feeling, opinion, taste, and results that please one viewer may leave another one cold. If, therefore, I am not very specific in the following, I beg the indulgence of the reader, who, I am afraid, cannot just sit down, relax, read my text, memorize a set of rules, and rise a better photographer. Instead, he must try to follow my reasoning (for which I can never offer any proof), critically consider what I say, draw his own conclusions, adapt my advice to his own type of work, accept it or reject it as the case may be, and emerge, if not a *better* photographer, at least a *more thoughtful* one.

I wrote this book for amateurs, for photographers who take pictures for pleasure rather than for gain, who have no boss or client to satisfy and therefore are in the enviable position of having to please nobody but themselves. This is the priceless advantage that amateurs have over professionals — they are free, they can do anything they like, they can go all-out in their

experiments, they do not have to worry about criticism or whether or not their pictures sell. I hope the reader will make the most of this fortunate situation.

Although most amateurs have artistic aspirations, they are, as a rule, not artists. This makes it possible for me to talk to them, to explain whatever can be explained about art in photography, and to guide them in the direction most likely to lead to further development of whatever talent they may possess. For the very fact that they take photography seriously (if they did not, they would not have bought this book) proves that there is at least a spark (and sometimes a genuine talent), latent, dormant, but capable of development and growth. Artists may occasionally write books, but nobody writes books for artists. Being incorrigibly individualistic, true artists have their own theories, go their own ways, intuitively doing the right thing at the right time, heeding the advice of no one. Presumptuous indeed would it be for me to tell an artist how to create great photographs. But in my twenty years of work as a staff photographer for *Life*, I have associated with many great photographers, have learned many things about photography, and have arrived at certain conclusions in regard to the creation of effective photographs. It is these conslusions I am here writing about.

However, merely writing about photographs and theories on photographic composition is often inadequate. The proof of such theories is in the effect their application has upon the viewer. Therefore, from here on, I must "go visual." As a result, in the following pages, information will be presented not so much in the form of words as in the form of pictures and accompanying captions.

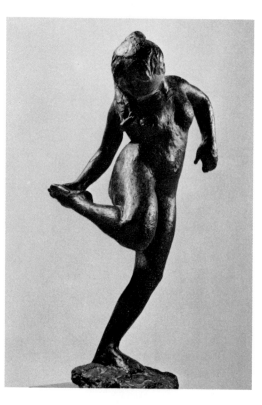 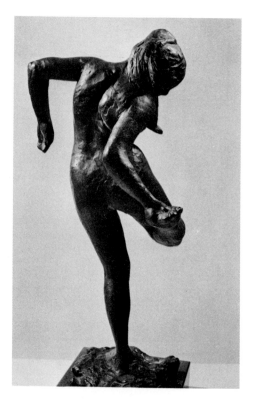

Subject position and angle of view

Dancer, by Edgar Degas. A small sculpture is excellent study material for evaluating the effects of different angles of view of the same subject in regard to clarity, beauty, and informative value. Placed against a neutral background as in the series above (to avoid confusing the issue with the additional problem of subject-to-background relationship), it can easily be handled, turned, studied from all sides, and appraised in every conceivable respect.

Evaluate this series particularly in regard to outline (silhouette) and overlapping of forms, pretending that only one of the four pictures could be used (perhaps in a book on sculpture). Better still, get hold of a small

56

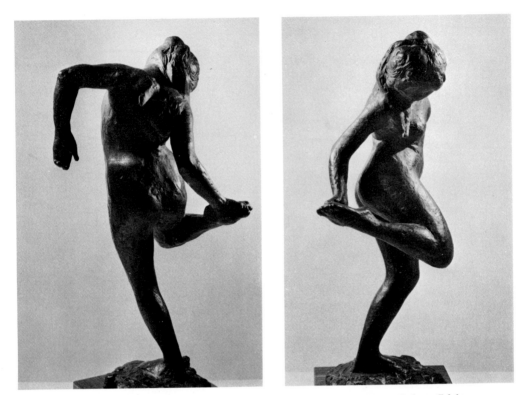

Andreas Feininger

figurine and do your own experimenting. Slowly turn the statue, observing it all the time, preferably on the groundglass of a camera, to neutralize the deceptive three-dimensional effect resulting from our stereoscopic way of seeing (see p. 24). Which of all the different angles do you like best? Why? When do the lines seem to flow rhythmically? Which is the most graceful pose? What about the outline of the figure? Does the tip of hair in the second view disturb you, perhaps because it seems like an unnaturally pointed breast? Do you object to the absence of the left arm in the last photograph? Personally, I do not like the fourth picture; I think the first one is a bit clumsy; and I can't make up my mind whether I prefer the third one to the second one.

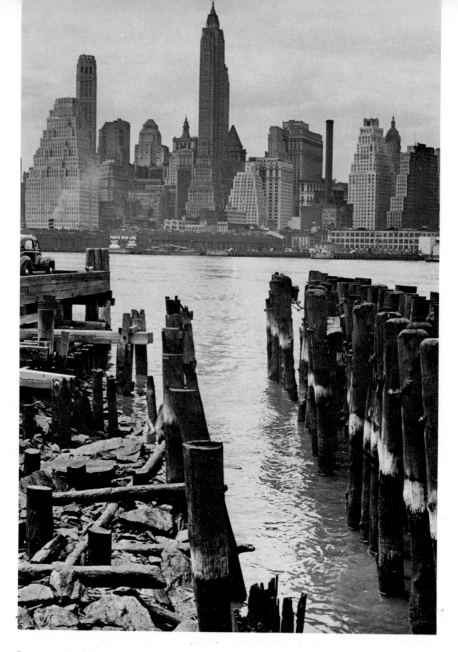

Camera position and angle of view

New York waterfront. Two views of the same subject taken from camera positions only a few feet apart—but what a difference in effect!

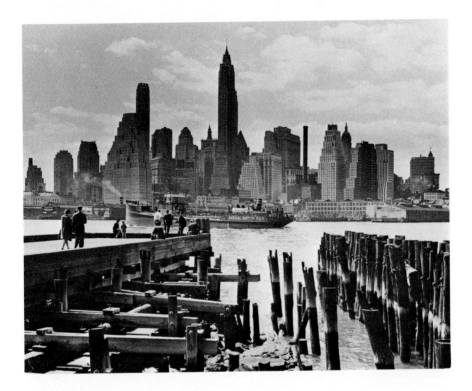

Above. The disorganized foreground containing both horizontal and vertical forms competes in tone and extent with the background (shore line dividing the picture into two nearly equal parts). The tanker, occupying the center of the view, blends with the background, "clogs" the composition, and compounds the confusion. The result: a wishy-washy, undistinguished rendition of a potentially impressive subject.

Opposite page. Repeating the vertical motif—the symbol of height—provided by the skyscrapers in the background in "negative form" through appropriate compositional treatment of the foreground—the narrow lane of open water—gives the picture a strong vertical direction. This is further emphasized by the pronounced vertical format (see p. 49). Contrast between extensive foreground and diminished distant background (position of the shore line high in the picture) creates illusions of depth and space. The result: a unified, satisfactory composition. Both photographs were made by the author.

Camera position and angle of view

Lighthouse at Montauk Point, Long Island, N. Y. Two views of the same subject taken from different camera positions within a few minutes of one another. Both were made by the author.

The lefthand shot was made in sidelight through a red filter in order to darken the prominent sky and give the view a feeling of air and spaciousness.

The righthand shot was made in backlight, for a silhouette effect, with particular emphasis on the foreground to create a feeling of distance and height through contrast between the large rocks near the bottom of the picture and the small buildings near the top.

Neither view is better than the other; they are merely different. Together, they prove that even a simple subject can be composed in many ways, each emphasizing different qualities of the original. Creative photographers, aware of this, study their subject in depth (see p. 21) before they commit it to film and paper. Which of all the possible forms of composition they choose depends on the effect they wish to create.

Camera position and angle of view

The bird's-eye and the worm's-eye view. Let me repeat for emphasis: Any subject can be composed in many different ways, and the first impression is rarely the best. Sometimes, a level view is satisfactory; other times, a downward (bird's-eye) or upward (worm's-eye) view gives better results. This, I felt, was the case in regard to the two scenes reproduced here, both of which were deliberately composed along diagonal-dynamic lines in an attempt to strengthen the feeling of depth, height, and motion. Even the upward soaring of a tall building can be experienced as latent motion in a vertical direction. (More about this subject on pp. 120–122.)

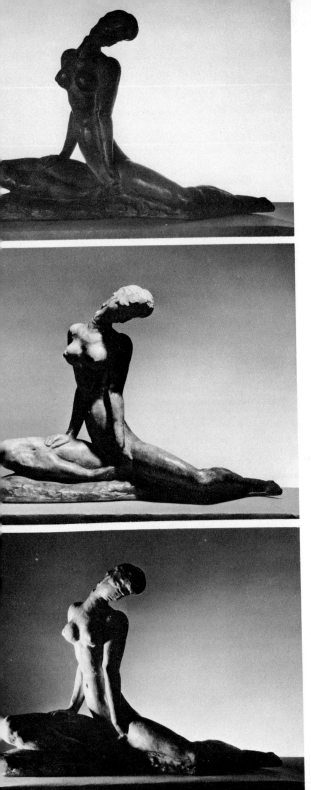

The role of the illumination

Dancer, by Wilhelm Lehmbruck. Determination of the proportions of the future picture is only one of the many steps in the process of composing a photograph. Selection of the most effective angle of view is another, and arrangement of an appropriate illumination is a third. Its purpose? In the two-dimensional realm of photography, it is the interplay of light and shadow that creates illusions of roundness, depth, and space.

Again, experimenting with a small and easily managed statue is perhaps the simplest way in which a photographer can familiarize himself with the effects of light and shadow. The photographs on this page, identical in every respect except illumination, as well as the two pictures on the opposite page, demonstrate how varied are the results that can be brought about solely with the aid of light.

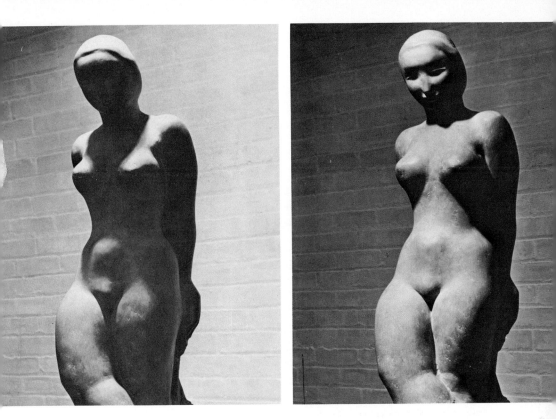

Young Girl, by Oronzio Maldarelli. The purposes of any illumination are to express the intentions of the photographer in spatial and graphic terms; to create illusions of three-dimensionality; to separate graphically the various parts of the subject from one another; to emphasize important picture elements with light while at the same time subduing distracting or superfluous ones by keeping them in the shade; and finally, to separate subject and background by making the one appear light where the other one is dark.

Note what different impressions can be created through appropriate manipulation of one's photolamps—from dark against light to light against dark. But despite their differences, each of these pictures is not just an exercise in lighting, but a finished photograph, each expressing in a different way something of the essence of the sculpture. Study their differences, figure out how each one was illuminated, then decide which version you like best.

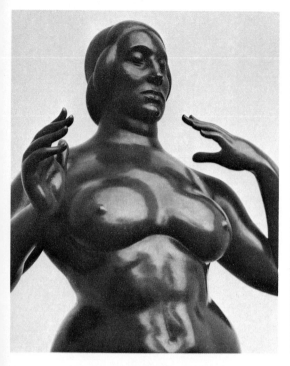

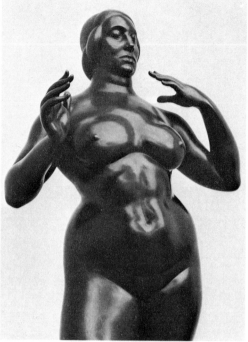

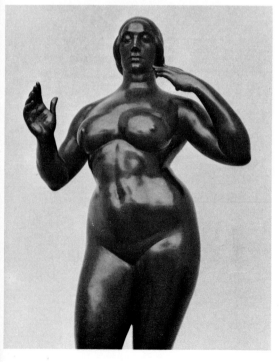

Cropping on the film

Standing woman, by Gaston Lachaise. Not always is the strongest impression achieved by a rendition that shows the subject in its entirety; often, a part can have a more powerful effect than the whole. In people photography, for example, the close-up of a face is usually more interesting, often more beautiful, and generally more informative than a shot of the entire figure; and sculptors have long since known that the torso—the figure minus head, arms, and legs—expresses the essence of the human body in the most condensed form.

Photographers wishing to take advantage of this principle of cropping must learn where to draw the line—what to show in their pictures and what to leave out. Again, the sculpture of a human figure provides an excellent point of departure for studying different ways of cropping.

The reader is urged to evaluate the effect of these five interpretations of a famous statue by Lachaise in several respects: angle of view (outline and silhouette, overlapping of forms, see pp. 56–57); lighting (illusion of three-dimensionality, distribution of light and dark, see pp. 64–65); and cropping. Subsequently, he should decide which version he likes best, and why.

These, as well as the photographs on pp. 64–65, were made by the author.

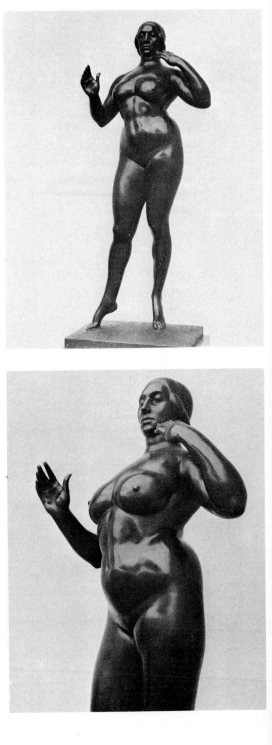

Cropping the print

It is always advisable to compose the future picture as carefully as possible before shooting it, because the few corrections that can be made during enlarging are limited to rather superficial aspects of composition. *It is not possible to change* during printing such vitally important factors as: relationship of subject (or foreground) and background; overlapping and juxtaposition of forms; perspective and most types of perspective distortion; distribution of light and shadow; nor to add inadvertently omitted parts of the subject.

On the other hand, it is understandable that, in the excitement of the shooting, a photographer either overlooks or simply does not have the time to render properly minor aspects of the subject. A number of the resulting compositional flaws can subsequently be corrected during printing, among them the following:

A composition containing two or more potential subjects can be broken up into two or more separate prints as demonstrated on pp. 70–71.

A composition in which the main subject of the picture is surrounded by too much extraneous detail can be tightened — and thereby strengthened and made more effective — by cropping off the superfluous parts and enlarging the rest.

Provided the negative is sufficiently sharp, not too grainy, and the fault not too severe, a subject rendered in too small a scale on the film can be enlarged (*blown up*, in professional jargon) and become an effective picture.

The proportions of the picture can be changed drastically. Square negatives can be made to yield horizontal or vertical prints of any proportions. Horizontal or vertical negatives can be converted to still narrower, longer, or higher formats or squares. Horizontal views can be transformed into vertical ones, and vice versa. However, prerequisite for most of these trans-

formations is that the subject is not rendered too tightly cropped on the film but surrounded by a certain amount of space, a safety margin, without which, as I pointed out before (p. 54), adjustments of this kind may be impossible.

Ineffective or ugly picture boundaries can often be converted into effective ones by making minor adjustments through cropping during enlarging. In this respect, three rules apply, the only "rules of composition" to which I have never found exceptions:

1. Small white areas of subject or background matter touching the edges of the picture and running into the margins make the print look as if rats had nibbled at its boundaries, an effect that will appear the more unsightly, the darker the surrounding areas. Such white spots should be darkened (burned in) during enlarging.

2. Round forms and curving lines near the picture margins must never touch the edges of the print. They should either be separated from the edge by a sufficient amount of space, or be boldly cut into during cropping, *i.e.*, an ample part of the curve should be sliced off in the print.

3. Lines running more or less diagonally toward one of the corners of the picture must never run exactly into and "split" the angle formed by the horizontal and vertical edges of the print. Instead, they should run into either the vertical or the horizontal margin, always at a distance from the corner.

Photographers who take their cropping seriously usually start by making a print of the entire negative, then study possible ways of cropping by means of two fairly large pieces of cardboard, each cut in the form of an equilateral "L." In conjunction, these two "L"s permit a photographer to form rectangles of any desired proportions and sizes up to the length of the arms of the "L"s. With the aid of these "L"s, he can isolate any part of the picture in any desired proportions (including, of course, the square) and study it independently from the rest. Sections considered for subsequent enlarging can then be indicated on the master print with a China marking pencil, which can be wiped off with ordinary cleaning fluid without leaving marks.

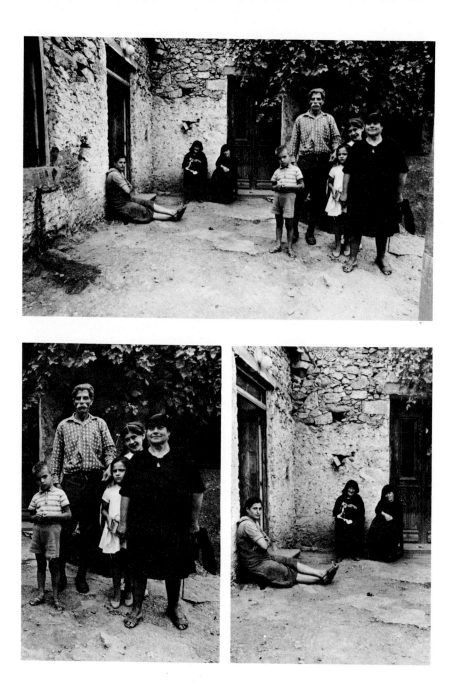

Cropping the print

Cretan family, by John Veltri. A typical example of a photograph which, although beautifully composed, can advantageously be broken up into a number of separate pictures, each representing an effective composition.

Study the individual pictures, paying special attention to the way in which Veltri balanced his compositions by placing the figures in the most effective locations within the framework of each photograph; the manner in which he subdivided space; how he chose his print proportions; and how he organized the distribution of light and dark.

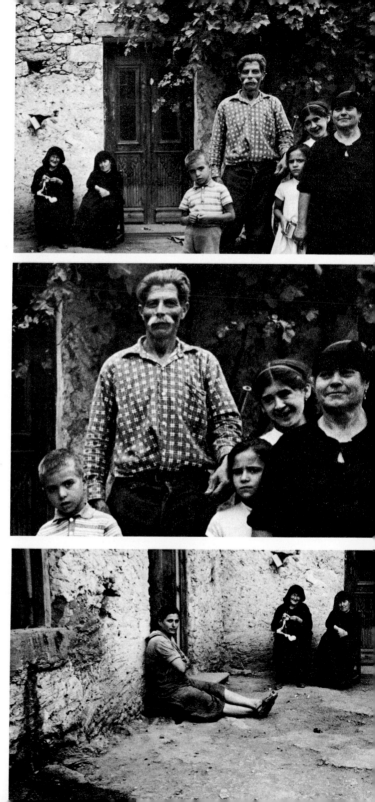

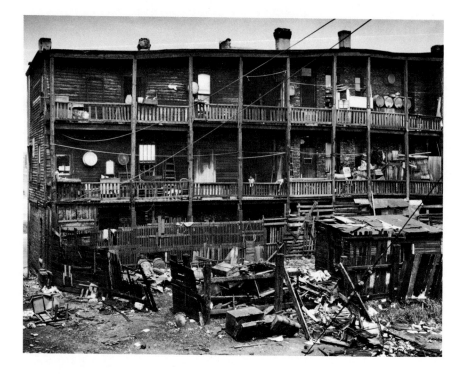

Cropping the print

Sometimes, as in the picture pair at the top of these pages, only small adjustments are required to improve a composition; other times, as in the pair at the right, more drastic corrections are needed.

Chicago tenement. Cropping off the sky (the part of the picture that weakens its message by suggesting light and air, besides diverting the eye from the subject) strengthens the composition. With the new cropping, the delapidated tenement fills the entire frame of the picture, undiluted by distracting elements.

Lower East Side, Manhattan. Converting the originally square photograph into a slim, vertical rectangle improved the composition by eliminating extraneous subject matter. The narrow format does more to suggest the depressing atmosphere of this decaying, overpopulated section of New York.

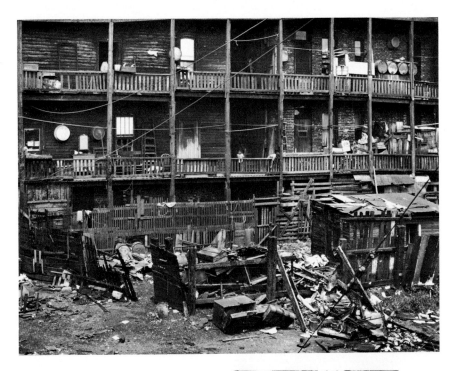

Andreas Feininger

Corrections during printing

Since we are on the subject of printing, this is the place to draw the attention of the reader to certain other printing processes by means of which he can improve the composition of his pictures and make unsatisfactory negatives yield satisfactory prints. Photographers who might object that these processes are of a purely technical nature and therefore outside the scope of this book are reminded of the fact that *anything* influencing the appearance of a picture is part of composition, whether it has to do with perspective, contrast, color, relationship of forms, or what have you. However, since the techniques on which these compositional corrections are based have already been discussed in detail in my other books, *The Complete Photographer* (Prentice-Hall) and *Total Picture Control* (Amphoto), I mention them here only briefly and refer readers who would like to know more about them to those books.

Perspective control. Photographs of architectural subjects in which actually parallel lines appear to converge can be corrected through appropriate enlarging (tilting negative and paper during projection). Thus, "distorted" negatives can yield "undistorted" prints, in which vertical lines appear parallel again. This kind of compositional correction can be a boon to photographers who work with cameras that lack swings, *i.e.,* the means for controlling perspective on the film.

Contrast control. In black-and-white photography, through use of a paper of appropriate gradation, the overall contrast gradient of a negative can be changed in the print, drastically if necessary. In addition, through local contrast control — burning in and holding back, or dodging — specific areas can be made to appear darker or lighter.

Lightness control. Through appropriate exposure during enlarging, a print can be made to appear lighter or darker in any desired degree.

Perspective control

Aesthetically, and therefore compositionally, it makes a great difference whether actually vertical lines are rendered vertical or converging in a picture. Photographers who know how to control perspective have a choice. By having verticals converge, through dynamic composition, they can express the concept of height; or by means of perspective control, they can correct the apparent converging of vertical lines in the picture and, through static composition, express the concept of solid monumentality.

Converging verticals are the result of tilting the camera upward or downward. To render vertical lines parallel, one of three techniques must be used:

1. The camera must be held level during the exposure.

2. If this is impossible, because it would result in cutting off the top of the building, a swing-equipped view camera must be used and the verticals made parallel with the aid of its swings.

3. If no swing-equipped camera is at the disposal of the photographer, a "distorted" negative can be corrected during enlarging by tilting both negative and paper accordingly. This method is illustrated by the two photographs above, both of which derive from the same negative.

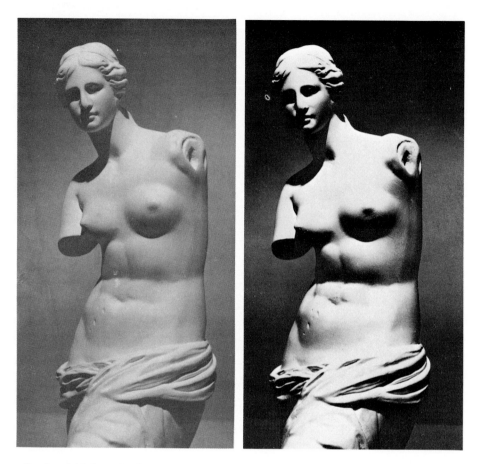

Contrast high or low?

Aesthetically, and therefore compositionally, it makes a great difference whether subject contrast is high, medium, or low. Photographers aware of these differences have it in their power to produce prints with virtually any desired contrast gradient by using a paper of the appropriate gradation. A "hard" paper yields prints in which contrast is high; a "soft" paper yields prints in which contrast is low. Since most papers are available in four or more different gradations, and since modification of exposure and development can further increase the contrast range of the print, freedom of choice is almost unlimited.

76

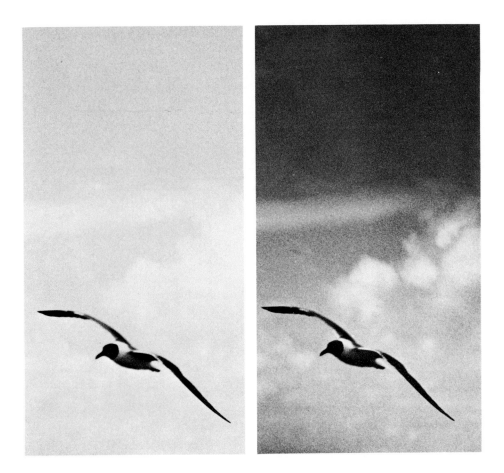

Lighter or darker print?

Aesthetically, and therefore compositionally, it makes a great difference whether the overall tone of a print is light, medium, or dark. A light overall tone suggests qualities like joy, happiness, youth, airiness, and so forth; a dark overall tone suggests concepts like seriousness, power, disaster, and death. Photographers aware of these differences have it in their power to achieve precisely the effect they desire: relatively short exposures during enlarging yield relatively light prints; prolongation of exposure yields prints that are correspondingly darker. A "normal" exposure produces "normal" prints.

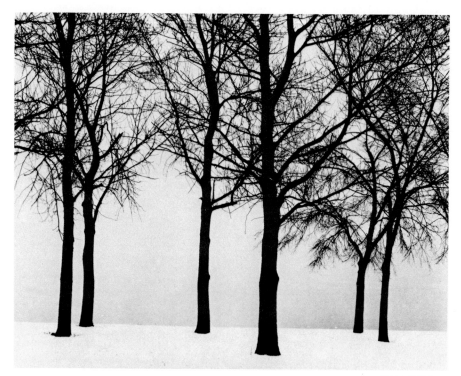

Harry Callahan

High contrast: black-and-white

Composition is synonymous with organization, organization implies clarification, and clarification profits from simplification. Now, what better way to simplify a composition than by means of high contrast and more or less pure blacks and whites?

Provided it is compatible with the nature of the subject, the purpose of the picture, and the intentions of the photographer, dropping out intermediate shades of gray in favor of blacks and whites is an almost infallible way of simplifying a rendition and, at the same time, strengthening its graphic effect. Dropping out the grays can improve a composition and, through elimination of unnecessary detail, clarify its meaning. The seven techniques by which these desirable results can be accomplished are discussed in detail in the author's book, *Total Picture Control* (Amphoto).

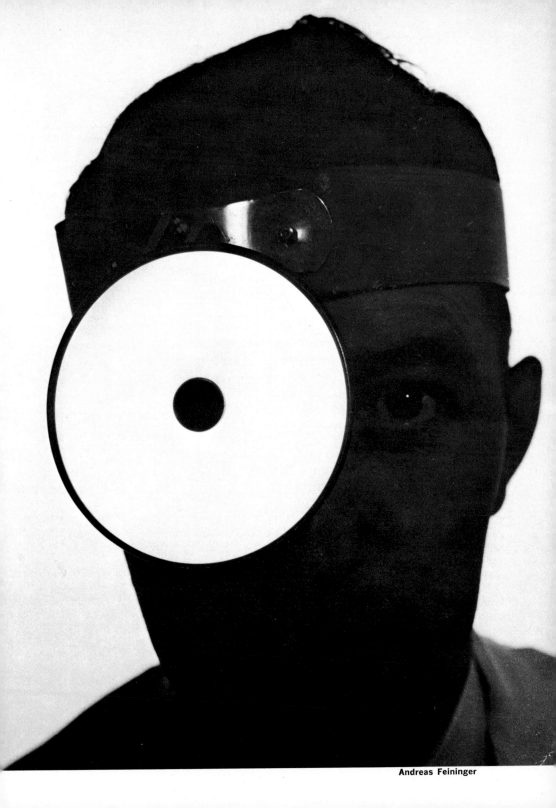

Andreas Feininger

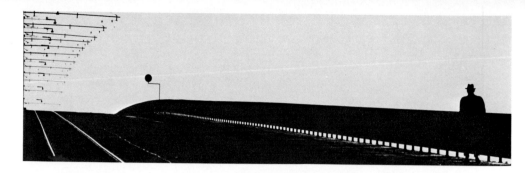

The Bridge, by Lennart Olson. Complete elimination of shades of gray simplifies the subject to such a degree that a rather commonplace view is transformed into a graphically powerful, semi-abstract composition of great beauty. Cropping the picture to the proportions of an extremely elongated rectangle suggests extension in horizontal direction (a typical aspect of most bridges), attracts attention by its unusualness, and eliminates superfluous areas of foreground and sky, thereby becoming a contributing element to the strong effect of this picture.

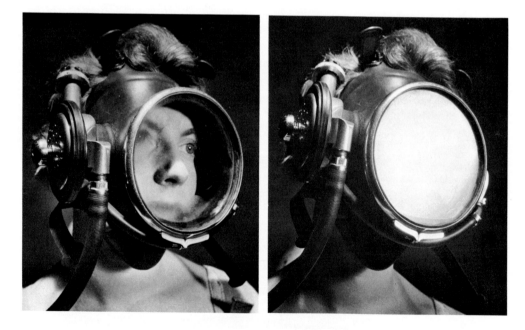

Lady diver, by Andreas Feininger. Increasing the contrast of the rendition through appropriate arrangement of the lights, until the faceplate shone like a mirror, turned an ordinary subject into an intriguing photograph—the picture of an old-fashioned brass locomotive headlight topped off by blond hair.

80

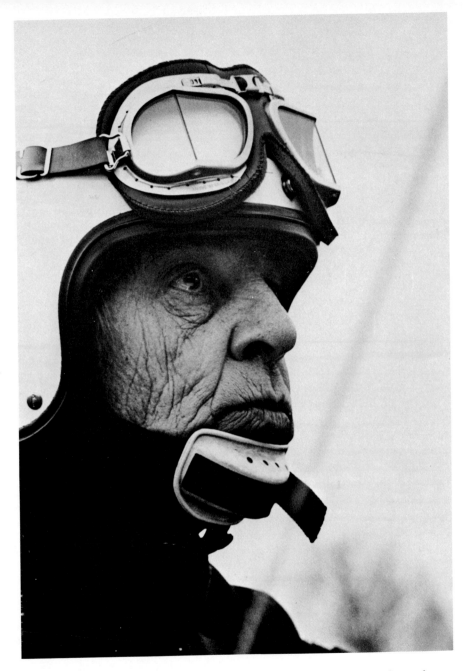

The Balloonist, by John Veltri. By deliberately choosing a high-contrast form of rendition, the photographer was able to create an atmosphere of masculinity while simultaneously emphasizing the graphically satisfying design.

The Golden Section

According to tradition, one of the most hallowed concepts of composition is the Golden Section (also known as the Golden Mean or *sectio aurea*), an age-old beauty canon designating a particularly pleasing ratio which was extensively used in their works by the architects and painters of the Middle Ages and the sculptors of classical Greece.

Expressed in mathematical terms, the Golden Section means that if we divide a line of a given length into two unequal parts, the ratio between the smaller part and the larger part should be equal to the ratio between the larger part and the entire line. This can be expressed by the following equation:

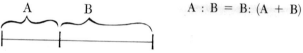

$$A : B = B : (A + B)$$

For example, if our line is 10 inches long, in order to divide it in accordance with the Golden Section, we must make the shorter part 3.819 and the longer part 6.181 inches long (3.819 + 6.181 = 10). This gives us the equation 3.819 : 6.181 = 6.181 : 10. This, of course, is the same as 6.181 × 6.181 = 3.819 × 10; if we complete the calculation we will find that the products of both sides of the equation are virtually the same: 38.20 and 38.19, respectively. However, since it is rather impractical to work with a ratio as complicated as 3.819 : 6.181, the Golden Section is usually expressed in the form of the ratio of 5 : 8, which, for practical purposes and especially the demands of photographic composition, is sufficiently accurate. The sometimes quoted ratio of 1 : 3, however, is much too far off the mark to yield pleasing results and should be avoided. In photography, the Golden Section is applied mainly for the following reasons:

• To establish pleasant picture proportions.

• To fix the position of the horizon.

• To divide a composition in pleasant proportions.

• To establish the location of the center of interest (compare the photograph on p. 84).

82

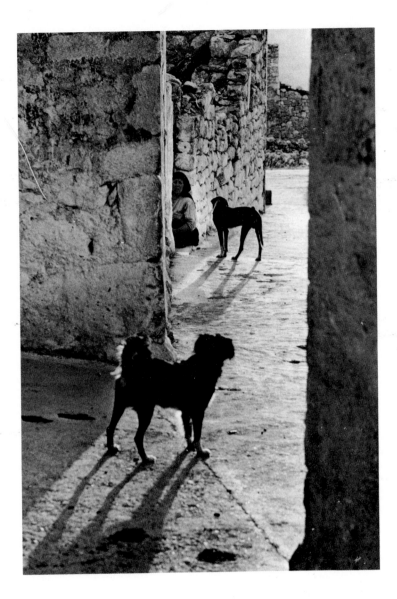

Greece 1969, by John Veltri. A composition in which virtually every important picture element—the walls, the dogs, the figure—is placed almost exactly in accordance with the Golden Section. The result is a photograph that, although superficially appealing, is traditional, stereotyped, tensionless, and in its overall effect rather dull.

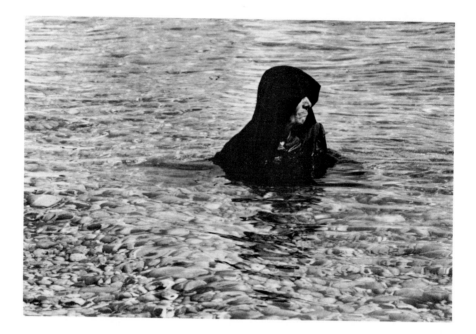

The Golden Section

Greek woman bathing in the sea, by John Veltri. Two versions of the same subject, with both prints made from the same negative.

Above, appropriate cropping during enlarging placed the figure within the framework of the photograph in accordance with the Golden Section, with the center of interest dividing the space both horizontally and vertically in the ratio of 5 : 8.

Opposite page, uncropped print shows the composition as the photographer conceived it.

The reader is urged to compare the two versions and decide which one he prefers, and why. I like the uncropped version better. In my opinion, it

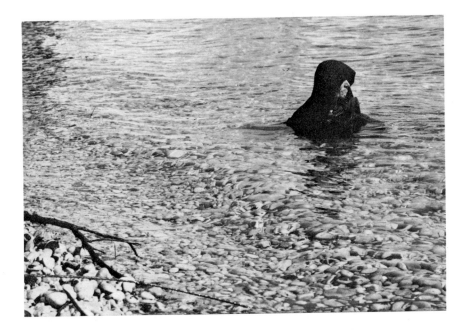

is compositionally superior because inclusion of the branch in the lower lefthand corner balances the figure, thereby completing the diagonal character of the composition. The implied diagonal, an imaginary line (see p. 93), suggests direction toward the upper righthand corner. This provides the picture with tension and thereby gives it life. This impression is further strengthened by the fact that the woman's head is turned toward the right, continuing the imaginary line. Having a figure gaze toward the near edge of the picture is, of course, a violation of one of the academic rules of composition (see pp. 18–20)—proof that these rules are not infallible.

As a matter of fact, it cannot be stressed enough that there are no rules of composition, least of all inviolable ones; there are only principles. But even these are to be taken merely as guides, open to interpretation and revision. If a photographer has strong feelings in matters of composition, I suggest that he express them in his pictures, regardless of what others may think.

V. The Elements of Composition

Regardless of its subject matter, any photograph can be conceived as a two-dimensional design consisting of lines and forms, gray shades and colors, areas of light and dark. These graphic building blocks of the picture are the elements of composition, the arrangement and relationships that a photographer must learn to control if he aspires ever to create effective photographs.

If, in the following pages, I talk about each of these elements in succession, it must be understood that such a step-by-step treatment is merely the consequence of practical considerations. Actually, as I stressed before, ALL the elements of a composition must be considered together and treated as a unit because a change in one invariably affects the rest.

In the last analysis, any photograph consists of only two elements: shades and lines. The shades consist either of color values or gray-tone values (including values of light and dark); the lines determine the boundaries and thereby the forms of the shades (unless the shades merge into one another gradually, in which case there are no lines). For practical purposes, however, it is advantageous to distinguish between the following types of lines:

- "True" lines, *i.e.*, lines existing in their own right and not merely as the outlines of shades.
- The outlines of shades (forms); such lines can be either straight, curved, or a combination of both.
- Lines which are actually narrow forms, yet which still succeed in giving a linear effect in the picture.
- Straight horizontal lines.
- Straight vertical lines.
- Straight tilting lines, including converging verticals and diagonals.
- Jagged lines.
- Curving lines.
- Leading lines.
- Lines of arrangement or composition.
- Lines of motion or force.
- The line of the horizon, even if such a horizon is actually the jagged skyline of a city.

Grasses, by Andreas Feininger. A semi-abstract study built entirely on the graphic potential of lines. The graphic center of the composition, the heavy cluster to the left of center, divides the picture horizontally in the ratio of 5 : 8. Cropping the tops of the longest grasses emphasizes their height—for all the picture tells us, they might continue upward forever. . . .

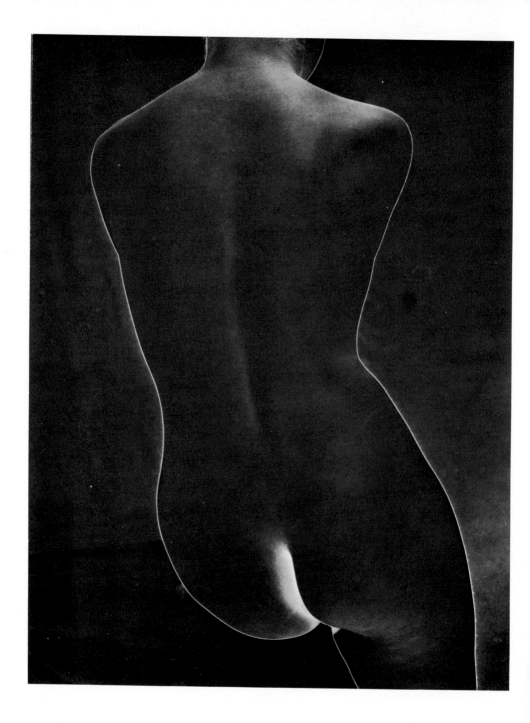

88

Two solarizations, the one at the left by *Erwin Blumenfeld,* the one above by *Andreas Feininger.*

In photography, "true" lines are rare, and photographers wishing to explore their potential might do well to turn to the photographic control processes *solarization* and *bas-relief* (the techniques of which are discussed in the author's book *The Complete Photographer,* published by Prentice-Hall). By enabling a photographer to increase subject contrast to any extent, including pure black and white, and eliminate superfluous detail to almost any degree, these techniques permit the creation of semi-abstract renditions, which in graphic power of expression rival the best work done in the graphic arts.

Two bas-relief compositions by Andreas Feininger. The bold and typically graphic black and white effect of these semi-abstract renditions is reminiscent of woodcuts, yet brought about by purely photographic means uncontaminated by manual interference.

The character of lines

As is frequently the case in matters of composition, in regard to lines, too, distinctions are not always clear and classification is ambiguous. In a seascape, for example, the juncture of sea and sky may equally correctly be classified as the outline of a shade (either the sea or the sky), as a straight horizontal line, or as the line of the horizon. Unfortunately, overlapping and fuzziness of concepts is one of the aspects of composition to which the reader will have to get used.

Most photographs, of course, contain any number of lines, the majority of which are of little importance in regard to the effect of the picture. The following discussion therefore applies primarily to the main lines of a rendition — the dominant lines — the lines that characterize a composition. As far as these lines are concerned, each kind has its own qualities and expresses specific concepts. Here is a short run-down as I see it:

The outline. This is the boundary line of a gray tone or a color shade. Compositionally speaking, the more decisive, simple, and bold the outline, the stronger the effect. The silhouette — a solid shade bounded by an interesting and characteristic outline — is one of the pictorially most expressive forms.

Lines that are actually narrow forms — thick, ribbon-like lines like the trunk or branches of a tree or the pole on p. 92 — are rather common picture elements. If they run the entire height or breadth of the picture, they usually become compositionally decisive factors; if they occur in multiple form, they may provide the basis for interesting pattern shots (see p. 126).

Straight horizontal lines suggest stability, permanence, tranquillity, reliability, and extension in the horizontal direction. This is the most static of all lines.

Straight vertical lines suggest extension in a vertical direction, height and, to a certain extent, stability since a vertical line (or form) is still in equilibrium, although not to the same degree as a horizontal line: One always has the uneasy feeling that a vertical line or form might tilt and fall.

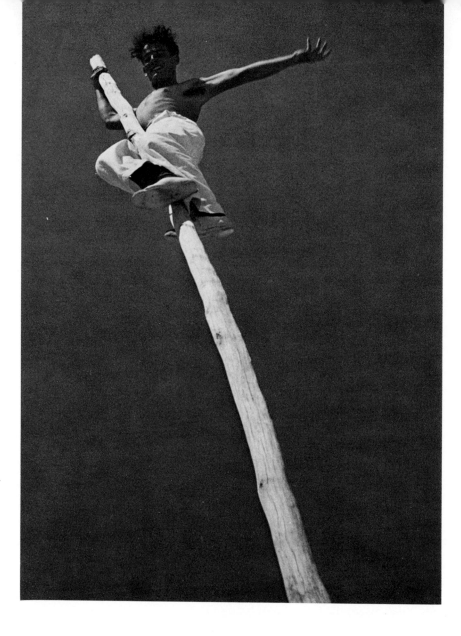

At the top, by Andreas Feininger. Example of a photograph whose composition is based upon a single line. Since the subject is a climber who has just reached the top, emphasizing the concepts of action, upward movement, and height became important. The natural impulse was to tilt the camera in order to render the actual vertical pole as a diagonal—the graphic symbol of motion, action, and height.

Straight tilting lines. Since they are among the most common of all lines, ordinary tilting lines have not much character and their effect upon the composition is usually negligible. But there are two important exceptions: converging verticals and diagonals.

1. *Converging verticals* are found primarily in renditions of man-made structures. They are vertical parallels that appear as converging lines, because the camera was tilted during the exposure. In this form, they represent the most powerful graphic symbol of height (or depth in vertical direction) in composition.

2. *Diagonals* are straight lines that run more or less from one corner of the picture to the opposite one; although, in reality, they may have been horizontals, verticals, or lines running in any other direction. Being neither "standing" verticals nor "fallen" horizontals, diagonal lines give the impression of toppling, and objects arranged along one of the diagonals of the picture seem to slide and move. As a result, the diagonal is the most dynamic of all lines, a graphic symbol of movement, action, and life.

Jagged lines, like the skyline of a city or the spruce-covered crest of a mountain, are the opposite of something smooth and quiet. They have an exciting and exhilarating effect, spicy and sharp.

Curving lines have a sinuous, smooth, rolling quality suggestive of quiet motion — or femininity.

Leading lines are the delusion of tradition-bound photographers with which I dealt already (see p. 19).

Lines of arrangement or composition are imaginary lines created by the more or less linear placement of prominent picture elements, analogous to a succession of dots, which produces the effect of a line. This kind of line can often be used to give a composition a specific direction in accordance with the characteristics of the subject.

Lines of motion or force. The gaze of a person looking in a specific direction, a reaching hand, or a car traveling from left to right — these are picture components implying direction along certain lines that often are important enough to serve as the basis for a composition.

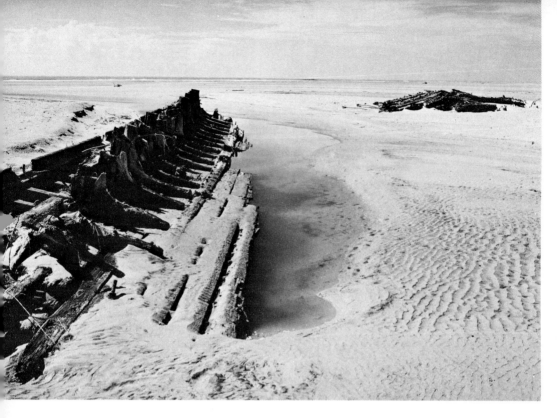

The "line" of the horizon

Ocracoke Beach, N. Car., by Andreas Feininger. The horizon divides a photograph into two parts, earth and sky, the proportions of which decisively influence the character of the picture.

A *high horizon* suggests earthly subject qualities and promotes the intimate view, the foreground, the soil, the detail.

A *low horizon* suggests lofty subject qualities and emphasizes the sky, air, clouds, and boundless space.

A *horizon dividing the picture* into two more or less equal parts gives equal emphasis to earth and sky, creating a monotonous impression—an effect that is desirable if monotonous subject qualities should be stressed such as an endless sandy beach, a stretch of dusty desert road.

A *level, straight-line horizon* should normally be rendered level in the photograph because even a slight degree of tilt looks sloppy and negates the typical horizontal character of the subject. If tilting seems desirable, as in a shot made from a banking airplane, the angle of tilt should be decisive, not so slight as to seem accidental.

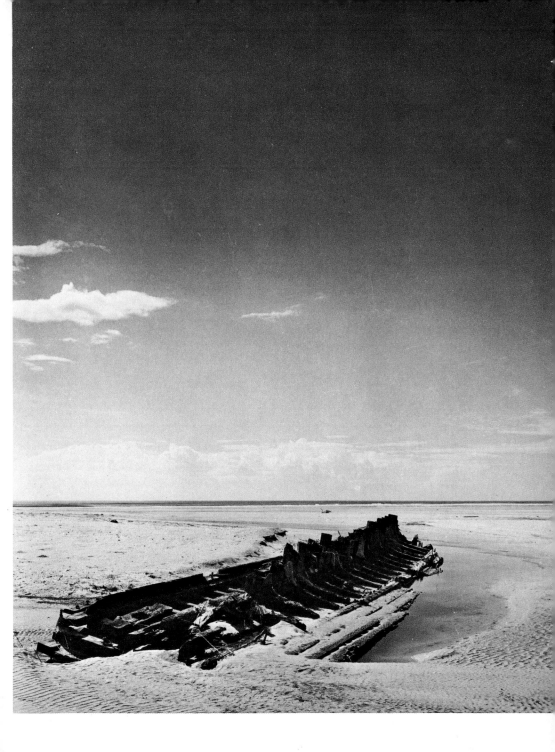

Composing with color

The fact that color is reproduced "automatically" in a color photograph does not mean that a photographer has to accept subject color as one of the unalterable facts of photographic life. On the contrary, to any graphically aware person, color is as much an aspect of composition as shades of black and white, contrast gradient, distribution of light and dark, perspective, and so on, but with the difference that, in a color photograph, subject color is the most powerful of all the factors that determine the graphic composition. All the more reason to pay particular attention to color and treat it as a dimension in its own right.

The importance of color as an element of composition is convincingly illustrated by the painting by Mondrian reproduced on the opposite page. Its powerful effect is the result of composition — the way in which the artist has chosen the shades, created the forms, and distributed the three primary colors, which are emphasized and made more luminous by contrast with "neutral" gray and black. Similarly, photographers who wish to make effective color photographs must learn how to compose with color in order to utilize its potential for the achievement of the best effects. In this respect, they have the choice of four different methods which, for best results, may be combined:

Selection and rejection. Photograph only subjects that are photogenic in color; reject those that are not. As a rule, a few significant colors are more effective than a riot of different shades.

Color filters. Light of unsuitable color produces transparencies in which subject color appears unsatisfactory; use of the appropriate color filter during the exposure can usually prevent this.

Time and patience. Subject color is strongly affected by the color of the ambient light, which outdoors changes with the time of day and with atmospheric conditions. If things do not look right the first time, waiting patiently or coming back another day often pays off in better photographs.

Darkroom control. With the aid of filtration during enlarging, photographers working with negative color film can change unsatisfactory subject color to almost any desired degree.

Photographers wishing to know more about the subject of color control can find complete information in the author's books *The Color Photo Book* published by Prentice-Hall and *Basic Color Photography,* published by Amphoto.

Above, Alexander Calder, by Andreas Feininger. Right, Compositie Parijs 1927, by Piet Mondrian (Stedelijk Museum, Amsterdam).

Both the photograph and the painting derive their effect from the contrapuntal relationship of three harmonious colors (red, yellow, blue) arranged in the form of a carefully balanced composition.

Note how, in the picture above, black, in contrast to its own darkness, makes color appear more luminous; and how, in the painting, the near-white of the background, in contrast to its own lightness, gives color added depth.

Left, Ascending balloon, by John Veltri. Juxtaposition of two comple-
mentary or strongly contrasting colors is an almost infallible way to achieve
the strongest color impact. And since composing means organizing, and
organizing is aided by simplification, it should be obvious that as far as the
number of different colors in a picture are concerned, less is usually more,
and gaudiness spells disaster.

Above, Balloon interior, by John Veltri. Combining a number of related
colors or color shades in one picture is another near-certain way of creating
pleasing effects. Distinguish between two groups of related colors: the warm
colors, red, orange, yellow, brown; and the cool colors, blue, blue-green,
purple-blue. Each of these colors exists, of course, in an endless number of
different shades, providing material for innumerable compositions, no two
of which will ever be alike.

99

Above, Battery Park, New York, by Andreas Feininger. Loud color is so commonplace today that it begins to lose its effect. Experienced color photographers know this and more and more use subtle, desaturated colors, which still are relatively rare in color photography and therefore command attention. Outdoors, they shoot on hazy or cloudy days; indoors, they work with subtle pastel shades and indirect, diffused light. And they know that a slight degree of overexposure produces lighter, more diluted, transparent colors than a normal, or shorter exposure—a subtle means of composition that they are quick to exploit.

Right, harbor scene, by Andreas Feininger. Gray (together with black and white) is one of the most important colors in any creative photographer's arsenal, because, in contrast to its own neutrality, it makes adjacent colors appear more vivid and rich.

100

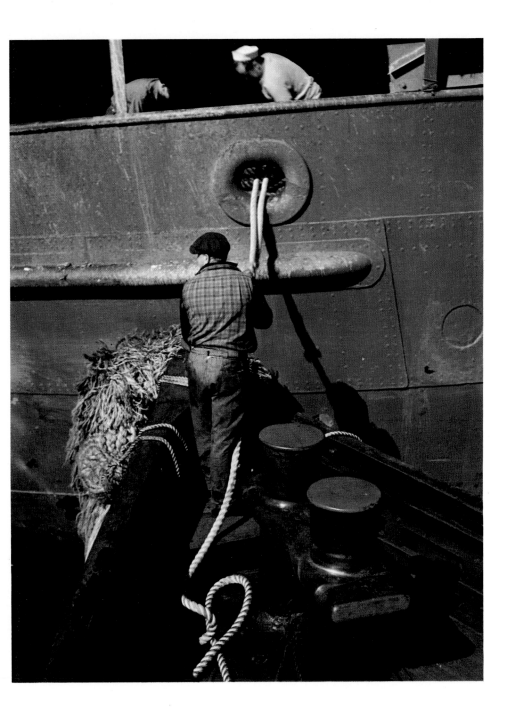

Left, Fashion model, by John Veltri. Above, Guggenheim Museum, N.Y., by Andreas Feininger. It is a sign of the beginner to think of color in terms of quantity; experienced color photographers evaluate color in terms of quality. They realize that the shade of a color is more important than the number of different colors in a picture; that different colors, no matter how beautiful by themselves, when used together can either harmonize or clash; and that black and white, although "colorless," are valuable components of any color photographer's palette because they play the following important compositional roles:

Black, in contrast to its own darkness, makes adjacent colors appear more luminous and bright.

White, in contrast to its own paleness, makes adjacent colors appear stronger, richer, and more "colorful."

Together, black and white permit a photographer to give his color pictures a high-contrast effect without having to pay the penalty in the form of overexposed light colors and underexposed dark colors since, obviously, it is impossible to underexpose black or overexpose white.

103

Background and foreground

When working out the subject-background relationship, experienced photographers make use of the fact that they have the choice of three types of background:

An unsuitable background, which, needless to say, should be avoided, detracts from the subject because it is: too obtrusive and loud; so similar to the subject in color, tone, or design that it more or less blends with it; or simply too ugly. How to deal with this kind of background has already been discussed (pp. 31–34).

A neutral background is unrelated to the subject, plain, and suitable in color and tonal quality insofar as it contrasts pleasantly with the subject without being obtrusive. Typical examples are white-, gray-, black-, or solid-colored cardboards, a white-washed wall, and the sky.

An integrated background directly relates to the subject or forms part of it. In the photograph on the opposite page, center row, right, for example, the sea directly relates to the sculpture although it does *not* form part of it. And the same applies to the picture at the bottom of the page, where the heavy shadow was deliberately introduced as part of the composition in order to enhance the subject.

At other times, it may be impossible to decide which is subject and which is background. This is true of the two photographs on the following spread. In the left one, the model quietly sitting in the background is just as much part of the "subject" — the reason for making the picture — as the young art student or her paintings in the foreground. And in the one at the right, the skyline of New York in the background is just as much part of the composition as the steel construction in the foreground, which belongs to the highway that makes the distant city accessible by car.

Other examples of integrated backgrounds are interesting cloud formations that complement a landscape; the stimulating and revealing clutter of a studio that provides the background for a portrait of the artist; and the bride and groom, which form the background for the wedding cake. Successful integration of subject, background, and foreground is one of the signs of a well-composed picture.

104

Three sculptures by David Smith

Top row, *left*, unsuitable background, too similar in tone to that of the subject, ugly shadows; *right*, clean, suitable background.

Center row, choice of background. *Left*, unobtrusive, clean, and suitable; *right*, suggestive background—the sea—complements sculpture entitled "Ad Mare."

Bottom, carefully placed shadow repeats in silhouette the subject's form.

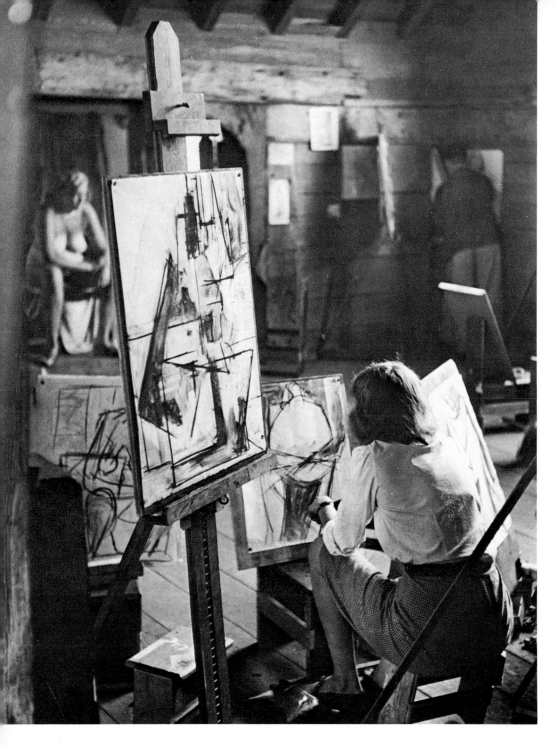

Cape Cod artist (left) and *New Jersey Turnpike construction*, both by *Andreas Feininger.* Examples of photographs in which the subject permeates the entire composition. Background and foreground are so thoroughly integrated that these terms, although spatially still meaningful, imply no longer any pictorial values.

The principle of scale

The most common reason why so many landscapes that appeared monumental to the eye turn out disappointingly in picture form is lack of scale. In reality, the photographer was surrounded by the three-dimensional immensity of space; in the photograph, this immensity is reduced to a two-dimensional image all of 8″ × 10″ large (all right — 40″ × 40″ if you project your transparencies) without a clue to indicate its actual size. No wonder the expected effect is missing.

However, the feeling of monumentality can be recreated in picture form by giving the photograph scale. By including in his composition an object of familiar size, a photographer can provide the viewer of his picture with a measure by which to gauge the size of the landscape.

The most effective indicator of scale in a landscape photograph is the human figure. Rendered in the form of a small image it makes a landscape appear large; conversely, rendered large, it makes the landscape appear small. To appear small, the figure must be placed at a sufficiently great distance from the camera. This makes the proper application of scale a matter of composition: where in his picture should a photographer place his measure of scale?

Analyzing the scene on the opposite page, we get a feeling of depth and space because the figures are rendered deliberately small. In contrast to their own smallness, they make the landscape appear large. They are placed high in the picture, thereby emphasizing the distance between foreground and background and symbolizing depth. This impression is amplified by the large rendition of the nearby footprints in the lower lefthand corner, which, in conjunction with the figures, form a diagonal (one of the imaginary lines of composition, see p. 93). The depth effect of this line is further strengthened by the movement of the figures toward the right, in the same direction as this line, turning it into an imaginary line of motion (see p. 93). However, to preserve the placid character of the scene, I introduced a second diagonal crossing (and thereby balancing) the first: the imaginary line connecting the two clumps of grass. The result is a composition indicative of boundless space — filled with tension and life, but in equilibrium and harmony with the subject and my reaction to it.

Cape Cod dunes, by Andreas Feininger. Analysis of the composition of this picture is on the opposite page. Keeping the sand and the sky in the same tone, by means of a pale blue filter, unified the composition. The dark accents appear like a design on a neutral background. Thus, the arrangement of pictorial elements corresponds to the character of this immense landscape where earth and sky seem to merge.

109

VI. The Forms of Composition

Having studied his subject in depth (p. 21) and considered his future picture in regard to individual aspects of composition, a photographer should now be in a position where he can weigh these factors against each other, decide which to use and which to reject, and take the final step by combining all the chosen elements in the form of a composition. In this respect, as all along the way, he once again has a choice, this time between two basically different forms — static and dynamic — although, of course, any number of intermediate states exist.

Static composition

A composition is static if its graphic elements appear to be at rest. This will be the case if the subject consists primarily of horizontal and/or vertical lines but contains no or only a few unimportant tilting lines; if the *dominant* horizontal lines are rendered in horizontal form and *all* the vertical lines in vertical form, *i.e.*, if they are *not* rendered in perspective, tilting or converging; if the main forms of the picture are organized in such a way that the overall effect is one of balance and harmony (which will usually be the case if the subject proper is more or less centrally located or more or less evenly fills the entire space of the picture); and if important lines of composition, movement, or force (see p. 93) are center-directed, *i.e.*, point more or less toward the middle of the picture.

A static composition is almost a necessity if a photographer wishes to evoke feelings of restfulness and peace, dignity, stability, reliability, firmness, security, grandeur, or undisputed strength; and if the subject is at rest, as opposed to being in motion. Typical examples of static composition are: all head-on views of people and objects, most undistorted renditions of architectural subjects, and most shots made with extreme telephoto lenses. An unusually intriguing and effective example of a static composition is reproduced on the opposite page.

Quartered, by Yoichi R. Okamoto. One of the main rules of academic composition states that a picture must never be divided into two equal parts, neither horizontally nor vertically. The artificial nature of this rule stands revealed by Okamoto's outstanding composition. It violates this tenet on both counts—transforms a commonplace subject into a fascinating photograph.

Examples of static composition

Above, Gas storage vessels. The composition derives its static character from the fact that this is a head-on view devoid of perspective diminution. Verticals are rendered in vertical and horizontals in horizontal form. The tank left of center divides the picture laterally in the ratio of 5 : 8 (p. 82).

Left, Fencer, composed to evoke the feeling of "calm before the storm"—the *en guard,* the static opening phase of the game. Having the rapier divide the picture into two equal parts, resulting in lateral equilibrium, heightens the static, balanced character of the composition.

Both photographs by *Andreas Feininger.*

Rockefeller Center, New York. Strict organization along vertical and horizontal lines creates a feeling of massive monumentality. Yet despite its static composition, the picture has its own kind of life resulting from the pairing of opposites: old and new; large and small; lifeless stone and living people, which, in contrast to their own small scale of rendition (see p. 108), make the structures in the background seem huge. Photograph by *Andreas Feininger.*

Greek monk, by John Veltri.

Symmetry in composition

Symmetry represents a particularly high degree of order, manifested in many forms, from classic temples to butterflies. Aesthetically, its effect upon a viewer ranges all the way from impressions of perfection and harmony to boredom. Photographically, symmetry is a static symbol of formality and monotony and therefore a valid means of composition, since formality and monotony are not always undesirable picture qualities. For example, most views of church interiors are taken symmetrically — on axis — in order to express formal feelings of tradition and reverence. And monotony is characteristic of some of the most awe-inspiring landscapes — boundless deserts and plains — and can best be expressed through symmetry, in this case, by letting the horizon divide the picture into two equal parts; or as in the photograph by the author on the opposite page, through lateral symmetry — the vanishing point of the converging railroad tracks is placed at the vertical axis of the picture.

114

Andreas Feininger

Central composition

This is a static-symmetrical form of composition with the impact of a bull's-eye—it irresistibly draws the eye toward the center of the rendition.

A central composition can be enormously effective in cases where the subject consists of a complete and self-contained form, or where a number of important lines (real or imaginary, see p. 93) converge toward the center of the picture.

The photograph of a Greek woman bathing in the sea was made by *John Veltri*. The two other pictures—a view of Brooklyn Bridge in New York and a view into a huge naval gun—were made by the author.

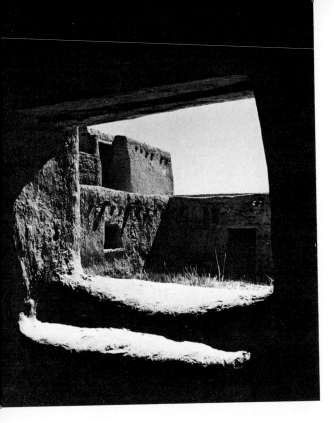

Acoma, by Andreas Feininger. One of the inner courtyards of the Indian mountain fastness, framed by the window of an adjoining room. The solid black of the window frame suggests shade, coolness, depth, and defensive strength besides providing interesting boundaries for the scene.

Framing the subject

A usually effective means of tightening a composition is known as framing, *i.e.,* surrounding the image of the subject with suitable foreground matter arranged to form a more or less complete frame.

Objects suitable to serve as a frame can be found almost anywhere: wrought-iron grills or fences, scrollwork of any kind, traffic and advertising signs, structures and constructions from building scaffolds to sculptures, tree trunks and branches, foliage, flowers, portals, doors, windows, openings, and holes of any kind and description.

Framing affects a photograph in three ways:

1. It strengthens the illusion of depth by means of contrast between near and far — the nearby foreground matter forming the frame in juxtaposition with the more distant subject proper of the picture.

118

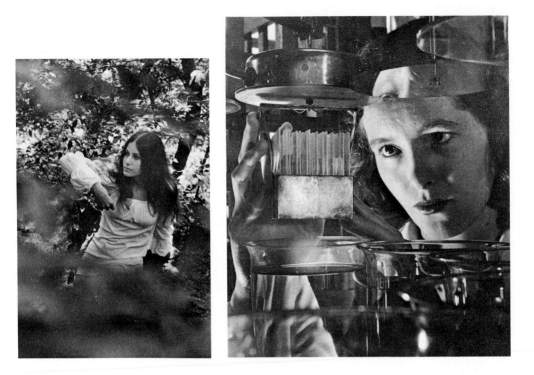

Left, Joan, by John Veltri. Out-of-focus foliage directly in front of the lens (selective focus, p. 34) effectively frames the figure of the girl while obliterating unwanted details of her surroundings.

Right, Laboratory technician, by Andreas Feininger. Framing the head of the girl by laboratory equipment accomplishes two things: it draws attention to the face, and it gives the viewer of the picture additional information about the girl's work. The bright spot near the lower margin is distracting and should have been toned down when the print was made.

2. The photographer can further increase this feeling of depth by rendering the framing element dark and the subject light. Contrast of dark and light is a photographic symbol of depth based on the fact that aerial perspective (depth indicated by atmospheric haze) makes distant objects appear lighter, the farther away they are, while nearby ones, less affected by haze, appear correspondingly darker.

3. By utilizing the frame as a graphic device for gathering the components of the picture more tightly together and isolating them from outside influences, a photographer can give his composition a degree of self-sufficiency that a frameless photograph of the same subject might not have had.

119

Andreas Feininger

Dynamic composition

A composition is dynamic if its graphic elements give the impression of being in motion. This will be the case if the subject consists primarily of tilting or diagonal lines and contains no or only a few unimportant horizontal or vertical lines; if actually horizontal or vertical lines are rendered in perspective, *i.e.*, converging or tilting and *not* parallel; if the main forms of the picture are organized in such a way that the overall effect is one of asymmetry, motion, and action, which will normally be the case if the subject proper is located near one of the edges or corners of the picture (instead of more or less in the center); and if important lines of composition, movement, or force (see p. 93) are outward-directed, *i.e.*, point toward the edges or corners of the picture.

120

A dynamic composition is almost a necessity if a photographer wishes to evoke feelings of action, motion, speed, and life; excitement, drama, and violence; powerful emotions and struggles mental as well as physical. Typical examples of dynamic composition are upward and downward views (the so-called worm's-eye and bird's-eye views); "distorted" renditions of architectural subjects in which verticals converge; photographs in which subjects in motion are blurred because they were made with shutter speeds insufficiently fast to stop the motion; and most shots made with extreme wide-angle lenses.

Dynamic balance is the name of a form of composition halfway between static and dynamic. It is static insofar as the elements of the picture are in "optical balance"; it is dynamic because the arrangement is asymmetrical. Essentially, a composition in dynamic balance is analogous to a scale loaded with equal weights of different specific gravity, for example, one pound of iron on one side and one pound of wood on the other, a situation that would look like this:

Although graphically asymmetrical (and therefore *apparently* unbalanced), actually these two weights are in equilibrium and therefore represent a static situation, a fact that would be obvious to any graphically sensitive viewer who subconsciously experiences a *dark* form as having greater "weight" than a *light* form. On the other hand, because of their asymmetrical arrangement, these two forms *seem* to be unbalanced — and unbalance is a state of tension, a dynamic concept in photography. This inner conflict, this duality of effect, makes this form of composition particularly suitable in all cases in which the subject has both static and dynamic qualities.

Incidentally, a master of this form of composition was the Dutch painter Piet Mondrian; two of his works are reproduced on pp. 15 and 97 and should be analyzed by any serious student of photography.

Above, three views of New York's Gulf Western building, an immobile, basically static subject, which, however, evokes a powerful feeling of height and dynamic soaring power.

Left, typical static composition—tiers of horizontal lines bound by vertical walls rendered in the form of parallels symbolize concepts of massiveness and permanence.

Center, dynamic balance—static and dynamic elements combine: on one hand, the balanced, more or less centered, and symmetrical arrangement; on the other hand, the tilting lines of converging verticals.

Right, dynamic composition—no static picture elements are left, the composition consisting entirely of tilting horizontals and converging verticals, arranged along diagonal lines of force thrusting upward.

Static or dynamic composition?

Let me repeat: A photographer almost always has a choice between rendering his subject in the form of a static and a dynamic composition. How the same subject can be presented in either one of these forms is illustrated by the comparison photographs on these two pages.

122

Two prints made from the same negative. *Above,* tilting the image of the locomotive creates a feeling of motion. Diagonal lines of composition reinforced by the imaginary line of force suggested by the forward thrust of the locomotive, combine to evoke the sensation of speed.

Left, straight up-and-down composition produces the static impression of a locomotive standing still.

Left, *Cross commemorating the site of a fatal highway accident in Arizona, by Andreas Feininger.* Tilting the main lines of the composition implies motion, action, and drama. These impressions are further strengthened by the slightly blurred rendition of the truck highballing down the road.

The sculptor Cecil Howard, by Andreas Feininger. You always have a choice—in this case between a static (left) and a dynamic composition (above). Which one is preferable depends on the nature of the subject, the intentions of the photographer, and the purpose of the photograph.

Pattern and composition

A favorite pastime of many amateurs is to hunt for subjects that make good pattern shots, *i.e.,* photographs in which more or less the same picture element is repeated over and over again in an orderly fashion. Perhaps they feel instinctively that the essence of composition is organization — and what type of picture could be more highly organized than a pattern shot?

However, there is a flaw in this reasoning: Composition is a photographic tool, a means to an end, a device to present a worthwhile subject in the most effective graphic form. In other words, the emphasis is on the subject. But in the average pattern shot the emphasis is on the composition, since apparently any subject that lends itself to this form of graphic presentation will do, no matter how boring, meaningless, or trite. For this reason, in my opinion, pursuit of the average kind of pattern shot is one of the most sense-less of all photographic exercises, unless, of course, the pattern will form an exciting abstract composition or represent an important quality of a worthwhile subject.

Pattern shots consisting, for example, of the shadows of wire chairs on a sunny terrace, stacks of lobsterpots on a wharf, machine components lined up on shelves, or two dozen naked baby-dolls in a box are, as far as I am concerned, exercises in futility, the kind of picture to which almost anybody but a *cognoscente* will react with a disparaging "So what?" On the other hand, patterns created by the streets and houses of a modern subdivision seen from the air, or the thousands of lit windows of a great city skyline at night, or the shadow cast by an elevated railroad trestle, or the pattern formed by the cracks in a concrete silo, or any one of the millions of patterns that in themselves are *significant attributes of a worthwhile subject* are, in my opinion, legitimate targets for pattern shots. Provided they are presented in a form designed to enhance the characterization of the subject, they can make effective photographs.

The photographs by the author shown opposite and on the following two pages are samples of subjects which, I feel, are strongly characterized by their pattern. Of these, only the shot of the facade of a modern office build-ing is a pure pattern shot, forming an intriguing and at the same time sig-nificant design. The rest present the pattern in relation to the subject, a form of composition that not everybody may espouse.

Left, facade of a modern office building, a pattern shot characterizing the essence of this kind of structure, here organized along static, centrally directed lines.

Above, grain elevator in Nebraska. Cracks in the concrete, repaired with an asphalt mix, form an abstract design. The static character of the silo is emphasized by a static composition—verticals are rendered parallel.

Both photographs by *Andreas Feininger.*

Composition in practice

The reason why, as a rule, *good* professional photographers (there are many bad ones, too) make better photographs than amateurs is NOT that they use superior equipment. Many amateurs own exactly the same Leicas, Linhofs, Nikons, Hasselblads, and so on and use the same kinds of film. It is NOT that professionals have access to superior film developing and printing facilities. Amateurs are free to use precisely the same commercial services. It is NOT that professionals know more about the "technical" side of photography. Most amateurs are surprisingly well informed in this respect, and many have an immense theoretical knowledge. It is NOT that professionals have access to more interesting kinds of subjects than amateurs. Both photograph people, objects, landscapes, scenes from daily life, and so on; and as far as the effect of a picture is concerned, it makes no difference whether the name of the subject is a world-famous one or Jane Doe. No — the difference in effectiveness between photographs made by good professionals and average amateurs is due to the difference in attitude.

Amateurs, as a rule, stumble on a subject that appeals to them, take one look, get excited, and shoot. They are satisfied with a single exposure (because film costs money!) and proud of the fact, for, in their opinion, shooting up a lot of film on a single subject is a sign of insecurity. "The man obviously doesn't know what he is doing and apparently hopes that, according to the law of chance, if only he wastes enough film, one of his many pictures is bound to be a hit." Needless to say, this kind of attitude is a sure invitation to failure.

Professionals, on the other hand, rarely go out hunting for subjects; instead, they become interested in a *specific* subject (or get a *specific* assignment). Before they reach for the camera, they study their subject from all sides and angles, and in every respect: in regard to its suitability for the intended purpose (particularly important if the subject is a model), its photogenic qualities, its surroundings, its background. They pay attention to the direction, quality, and color of the light. They carefully weigh subject distance and scale, angle of view, perspective, and, if necessary, motion. But especially they give thought to their future composition: How are they going to present their subject in the most effective graphic form?

The answer, as the professional well knows, depends on four different factors: the nature of the subject; the purpose of the picture; the audience for which the photograph is intended; and, above all, his own reaction to his subject. How does the photographer feel about a subject? What does he think? How does it affect him emotionally or intellectually? *What does it mean to him?* And not before he has arrived at specific conclusions does he reach for the camera.

But even at this crucial moment, there is a difference in attitude between professional and amateur (or should we by now say successful and unsuccessful photographer?). Most amateurs have their favorite camera (nowadays usually a 35mm single-lens reflex), which, they believe, can do everything. To a certain extent, this is true. There is no subject on earth that cannot be photographed with a 35mm SLR. But, in many cases, *better* results might have been achieved if a different kind of camera had been used — perhaps a larger one, or a still smaller one, or a panoramic camera, or an aerial camera, or a view camera equipped with swings. Professionals know this, and choose their camera accordingly.

When it comes to the actual shooting, professionals know that there never is only a single most effective view and that, furthermore, the first impression is rarely the best. Almost without exception, closer study will reveal still better views, more unusual, more significant, more exciting. Therefore, instead of being satisfied with a single shot, good photographers explore their subject in depth, literally as well as figuratively speaking, gradually warming up to it, getting attuned to the spirit of the scene, constantly discovering new and unexpected aspects, angles, qualities, color or light effects, getting better results with every shot they make. They know that the first pictures might just as well have been shot without film in the camera for all they are worth when compared with the later take. They are aware that film is expendable, their cheapest commodity, especially when evaluated in proportion to the rest of the cost of picture-making: travel expenses, model fees, assistant salaries, car and prop rentals, laboratory bills, and so on, not to mention the incalculable cost of missing a decisive shot because the photographer wanted to save on film.

The professionals know that if a subject is worth photographing, it is worth photographing well; that opportunity is a priceless one-time gift; and

that the only realistic way to save on film is to be more critical in the selection of their subjects. But once they have made their choice, they go all out. They shoot roll after roll of film, NOT because they feel insecure, but because they know that nobody can predict whether *this* shot might not turn out to be the best of the entire take, *this* pose or gesture, *this* expression, *this* configuration of people in motion, or *this* particular light effect. This is the secret of good composition, and of success. Think, feel, react. Then express the results in picture form in accordance with the suggestions made in this book.

The nine photographs on the opposite page — part of a take by John Veltri — demonstrate how a sensitive photographer explores a simple subject. The reader is invited to study each shot in detail, then see whether he agrees with my comments: (1) A good but conventional opening shot; the three branches are unfortunate. (2) Better, but too much view from below causes distortion; shoulder too light, detracts, should have been darkened in printing. (3) An excellent portrait; lower right corner too light, strands of hair or the shadow of branches would have helped. (4) The head is lovely in profile, but the figure appears too squat. (5) Better, but cropped too tightly at the bottom. (6) An excellent composition, the girl beautiful and proud. (7) A very appealing portrait; identical with the third picture except for a slight turn of the head — which do you prefer? (8) The photographer discovered the beautiful hair of his model, but failed to make the best of it; the branch is very disturbing. (9) Partial enlargement of the fourth picture saves what is good by cropping the rest.

Conclusions: (1) The more thoroughly a photographer explores his subject with the camera (*i.e.,* the more pictures he makes), the more he sees and the better his chance of getting good results. (2) Even slight changes in subject approach can make significant differences in the effect of the picture.

132

Twelve studies of the nude by John Veltri demonstrate how a photographer starts slow and conventional with shots of the entire figure; gradually works his way closer; becomes increasingly inspired and inventive in regard to posing, lighting, and cropping; and finishes by thoroughly exploring one particularly promising setup (the pictures on this page), which he shoots again and again, each time subtly varying one of the compositionally important picture elements.

135

Summing up

I am well aware that much of what I said in this book is theory, the gist of which will often prove difficult, and sometimes impossible, to apply in practice. Pure examples of the various aspects of composition as discussed here exist only in textbooks — reality is never quite as perfect as we would like it to be. Figuratively speaking, few things in life are either black or white, most are a lighter or darker shade of gray. And photographically speaking, few subjects or compositions are of an entirely static or dynamic nature; the majority will be found to have characteristics of both. To consolidate such contradictory aspects in a satisfactory form is then up to the photographer, on whose artistic and technical resources it depends whether the picture will fail or succeed.

But no matter how controversial and difficult, not to say elusive, the concept of composition, sooner or later a photographer must come to grips with it. How is up to him, because, as I said at the beginning, composing is an intensely personal affair. But before anyone can work out anything for himself, he must know what it is all about. In this respect, theoretical discussions have their use because they deal with fundamentals. And the fundamental aspects of composition provide the only basis on which anyone can build a philosophy of photography. To give the reader this basis is the purpose of this book — not to convert him to the author's opinions. To do more is impossible; from here on it is every man for himself.

ANDREAS FEININGER